IMAGES
of America

HILLSDALE

IMAGES
of America

HILLSDALE

Sean Smith

ARCADIA
PUBLISHING

Published by Arcadia Publishing
Charleston, South Carolina

Printed in the United States of America

Library of Congress Control Number: 2021932890

For all general information, please contact Arcadia Publishing:
Telephone 843-853-2070
Fax 843-853-0044
E-mail sales@arcadiapublishing.com
For customer service and orders:
Toll-Free 1-888-313-2665

Visit us on the Internet at www.arcadiapublishing.com

This book is dedicated to the early residents, governing members, and members of the emergency services of Hillsdale who formed this beautiful town that we call home. It is also dedicated to all of the generations that have passed through and have made their donations. Most of all, it is dedicated to the future generations who need to preserve the quaintness and the beauty for the future generations to enjoy.

CONTENTS

ACKNOWLEDGMENTS

This book about Hillsdale was conceived around 10 years ago at a historic preservation meeting when member Zoltan Horvath presented the idea to produce a published book about our much beloved Hillsdale. Even with the desire and some preliminary research, the vision did not come to fruition at that time. Fast forward to 2017. With a fresh and reformed historic preservation committee, the idea regained enthusiasm and momentum when re-presented by Horvath. This prompted committee member Marie Hanlon, a former George White School teacher, to ask the question: "Why doesn't Hillsdale have one of those books that are sold in local drugstores?" It appeared that all the surrounding towns had their own historic publication but Hillsdale. With the new historic preservation president Sean Smith now on board, the committee knew that Sean was a great asset because he had acquired a plethora of historic images and had garnered a vast knowledge of the history of the borough while previously doing research for a number of privately published books about the Hillsdale Police Department. The welcomed addition of Sean Smith proved to be the impetus for a winning combination. Zoltan Horvath's level of dedication, commitment to excellence, and a mission accomplishment credo paired with Sean Smith's love and enthusiasm for the town led them to the ultimate publishing of this book. They are pleased and excited to share this book with you and posterity.

In March 2020, the country was hit hard with the COVID-19 pandemic. The upside of that was that it gave them time to dedicate to this publication. With a little luck, based on the success of this first volume, they hope to produce a second volume.

The author acknowledges and recognizes the following people for their contributions of photographs and related provenance: David Franz, Peter Hard, Marie Hanlon, Keith Durie, Laurie Bartos, Jason Durie, George Lucia Sr., Bob Hubbard, George Jepson, Fred Winkler, Maria Mockler, the Hillsdale Fire Department archive, the Hillsdale Police Department archive, the Hillsdale Library, the Pascack Historical Society, and the many photographers through the ages who did not realize that their casual photographs would help to create a portal to time travel.

INTRODUCTION

Hillsdale's history has three stages: its farms, the village, and the suburb. From the mid-1700s, fields were cleared, and farmhouses were built over the entire area. Some of these Dutch stoned homes are featured in this book and still remain today.

For three generations, the village slowly expanded over field and farm along the farm roads; Hillsdale, Washington, Piermont, and Demarest Avenues; Yesler Way; and Pascack and Wierimus Roads are some of the original roadways.

During the mid-1800s, well-to-do New Yorkers were in search of a country vacation destination. The Pascack Valley's clear air and water and pastoral beauty provided a break from coal smoke, epidemics, and the hustle and bustle of the city. The arrival of the railroad in 1870, which was fairly new at the time, gave focus for the village, which began to grow in waves out from Hillsdale Station.

David P. Patterson, Esq., was a visionary who, along with others, was instrumental in bringing the railroad to the valley. This fast means of transportation would not only permit development of the land along the proposed line, but would also open the area for business. Patterson owned a large amount of land in the center of what was to become the village of Hillsdale. He was able to carry out his vision of a village when he brought a train depot to his land. His vision of the village becoming a railroad center was realized when car shops, an enginehouse, a calling station, a turntable, and a water tower all followed. This gave employment to a number of residents and brought a certain amount of prosperity to the area.

The line to the Hackensack and Pascack Valleys was called the Hackensack and New York Extension Railroad Company. It was an extension north of the Hackensack & New York Railroad's track, which was completed as far as North Hackensack in 1866. This company had been incorporated in 1856 as a franchise, giving it the right to continue to the state line, which it proceeded to do in 1866. On October 15 of that year, a contract was entered between the railroad and Patterson by which he and his associates were to obtain subscriptions to the capital stock for financing the reduction extension line, in at least the sum of $100,000, within a period of six months. Sufficient funds were raised to begin work on the extension, and continued financing carried the line to Hillsdale by December 1869. There, the work halted during the winter.

As part of the development of the village site when the railroad was approaching, the first general store was built along with a large four-story hotel called the Hillsdale House. The building still stands at the southeast intersection of Broadway and Hillsdale Avenue. There were six homes within a half-mile radius of the Hillsdale Station when the line formally opened for business on March 4, 1870.

A booklet by George L. Catlin was published in 1870, titled "Suburban Homes for City Business Men on the Line of the Erie Railway." The preamble of the piece describes the general area as follows: "a description of the country adjacent to the Eastern division and branches of the Erie Railway and Northern Railroad of New Jersey, together with a statement of the inducements offered for purchase of a suburban residence in the rich valleys of the Hackensack and Passaic,

the healthful mountain region of the Ramapo, or the fair fields of Orange County." The cover of the prospectus further glorified Hillsdale with heavy use of exclamation points as follows: "Choice locations for Country Villas, Cottages and Building Sites at Hillsdale, N.J. — Fine Mountain Scenery!! Rich Soil!! Pure Waters!! No Mosquitoes!!" Catlin described Hillsdale in glowing terms:

> Hillsdale, the present terminus of the road, and destined at no distant day, judging from the wonderful progress made during the last six months, to become an important center of trade and travel. The President of the Extension Road, D.P. Patterson Esq., resides near the depot, and within a circuit of a half mile are the abodes of a number of old and wealthy inhabitants of the county. A large hotel, capable of accommodating 250 guests, is in course of erection, a fine new country store, well stocked, is already in operation adjacent to the station and quite a number of dwelling houses are going up within a stone's throw of the spot. The Village of Hillsdale has a population of about 2000, contains two schools, a church (Dutch Reformed), a spool manufactory (75 by 100 feet in dimensions, and five stories high), and for turning mills, all in operation.
>
> The Pascack Creek, formed by the confluence of several large brooks, furnishes a water power sufficient for 14 mills, and, in this respect, the advantages of Hillsdale are especially worthy of consideration. But its claims as a place of residence are equally strong. The country is open and well cultivated, the air is clean and healthful, the water pure and the soil very fertile. The country roads afford opportunities for delightful drives or rambles. . . . Within a half a mile from the Hillsdale Depot one may purchase an acre of good land for $500, while city plots, easily accessible from the cars, can be had at from $300 to $500."

It was not until 1898 that the borough of Hillsdale broke away from its own entity. Hillsdale's name was derived from its first schoolhouse, built in 1856, and the railroad station, constructed in 1870. In 1906, the easternmost part of Hillsdale broke away and became part of what is now River Vale, leaving Hillsdale the size and shape it remains today.

The first migration of residents proceeded at a leisurely but steady pace through World War I. The population increased in tempo with improved public transportation—more rail service and the establishment of bus routes. The automobile and the George Washington Bridge began to alter Bergen County radically, but Hillsdale was still distant from the urban areas. Finally, World War II brought Hillsdale into suburbia with a rush. In the past 70 odd years, Hillsdale's population has tripled and has become the town we know today.

This book concentrates on Hillsdale from the late 1800s, the village era, up to the end of the World War II. These early villagers and pioneers deserved to be memorialized for leaving us the foundation of a special town called Hillsdale, New Jersey. As you travel through town, I hope you can envision some of these sites contained in this book and remember their sacrifices. Enjoy the amazing journey!

One

EARLY LIFE AND PEOPLE

As described in *Picturesque Hillsdale* (1899), "To those seeking homes in the country, Hillsdale offers attractions to be found in very few places; there is no malaria in the village or township of Hillsdale and the people are never troubled with those pests, the mosquitoes, which makes life miserable to so many residents of towns near New York. The air is clear, dry and bracing, and has been found to be beneficial to those suffering from lung and throat troubles. The soil is sandy, and the water is the purest found in New Jersey, always clear and cool, having the same temperatures the year around. Trains on the New Jersey & New York (Erie) Railroad run frequently, over twenty-four a day both ways, many of them are expresses, making the distance from Jersey City in forty minutes. Elegant well-shaded building lots can be obtained at a very reasonable price. The Village is well lighted and the streets are clean, the Park question is settled and there will soon be a beautiful park opposite the station." (Courtesy Hillsdale Library.)

River scene, HILLSDALE, N. J.

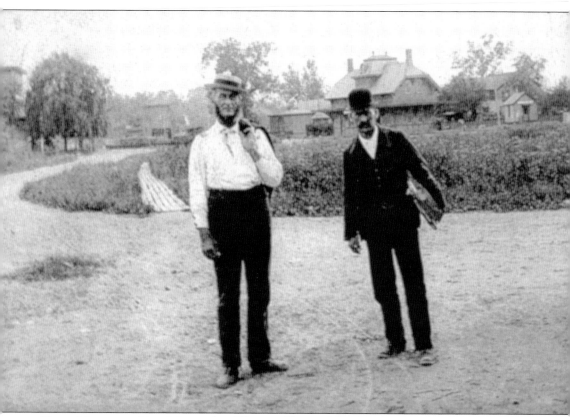

Henry Herring and his father-in-law Thomas Clinton Demarest are standing at the corner of Summit Avenue and Park Street in late 1890s. Pictured in the background are, from left to right, the Hillsdale Hotel, built in 1870; water tower for the train; Henry's General Store behind the train station; Thomas Demarest's farmhouse, which contained the first telephone installed in a Hillsdale home; and the station agent's shack. (Courtesy Bob Hubbard.)

John H. Riley, shown here, represented Hillsdale on the board of freeholders in 1902 and was the fire department's first president. Riley's wife was named Helen. (Courtesy Hillsdale Library.)

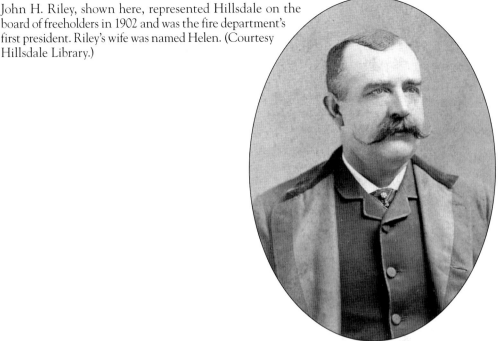

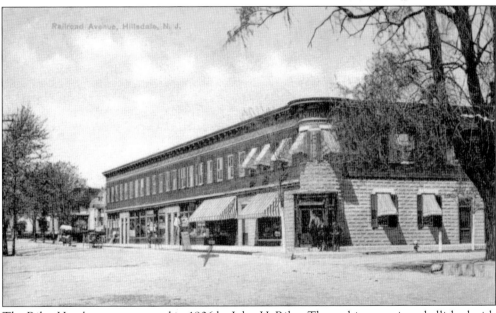

The Riley Hotel was constructed in 1906 by John H. Riley. The architecture is embellished with artistic concrete blocks, an oriel accenting its corner, and an elaborate pressed metal cornice with ornate modillions or brackets, frieze with garlands, dentil band, and egg-and-dart molding. The hotel was capable of accommodating 250 guests. John H. Riley ran a saloon at the corner store. The only entrance was one catty-cornered to Hillsdale Avenue and Summit Avenue in those days. Salvatore Marsala later purchased the building and ran the saloon before he went into the hardware business at this location. Marsala Hardware, established in 1929, remains in business at 110 Broadway. (Courtesy Hillsdale Library.)

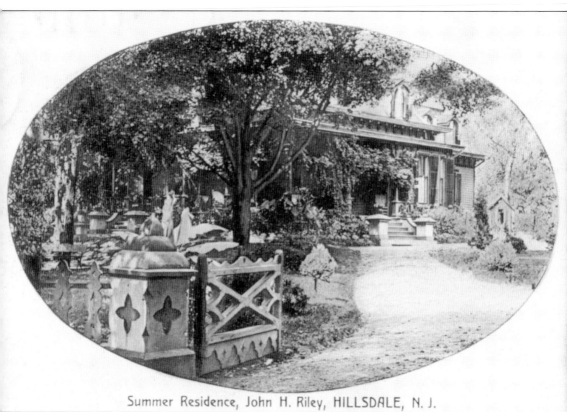

Summer Residence, John H. Riley, HILLSDALE, N. J.

Brook Side Pines is pictured here around 1860. This mid-19th-century example of architecture was the summer residence of John H. Riley and was located at 462 Hillsdale Avenue, the plot of the old St. John's Rectory. This Empire-style framed house was a country estate with beautiful, landscaped grounds and was the showplace of early Hillsdale. In 1908, John Riley's son Albert G. Riley, who lived at the residence, was shot by a burglar who attempted to break into the home. Charles Riley, Albert's younger brother, shot back at the fleeing burglar, wounding him. (Courtesy Hillsdale Library.)

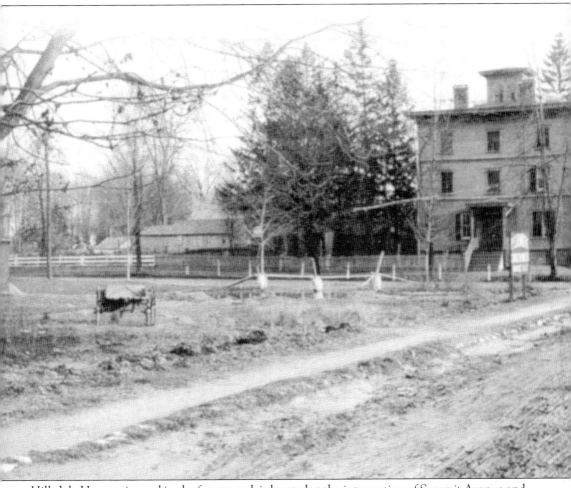

Hillsdale House, pictured in the foreground, is located at the intersection of Summit Avenue and Hillsdale Avenue. The first development in Hillsdale consisted of lots and villa plots sold by David P. Patterson, president of the Hackensack and New York Extension Railroad Company. Part of the Patterson land was later developed by Rachel Ackerman. (Courtesy Pascack Historical Society.)

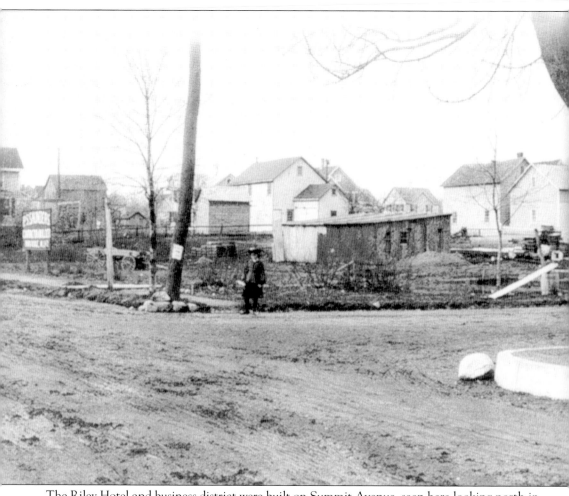

The Riley Hotel and business district were built on Summit Avenue, seen here looking north in the early 1900s. In 1902, these were the first streets to have macadam laid. The names of Railroad and Summit Avenues would be changed to Broadway by an ordinance in April 1923. (Courtesy Pascack Historical Society.)

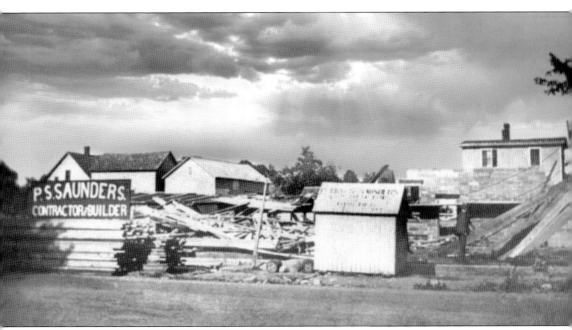

This photograph shows the destruction of the framework to the Riley Hotel after a tornado passed through Hillsdale in the early 1900s. It was learned from the son of Perry Saunders, whose construction sign shows in the picture, and from one of Riley's sons that the framework had been entirely completed when the storm came along and tore it down. The Saunders Company had to rebuild. (Courtesy Hillsdale Library.)

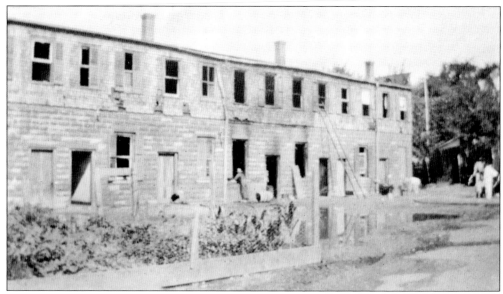

The Riley Building suffered major damage after a fire broke out in the butcher shop in the early 1900s. A dozen men pulled the hook-and-ladder truck from the firehouse as they could not get horses from Gardinier's Livery Stable in time. (Courtesy Hillsdale Library.)

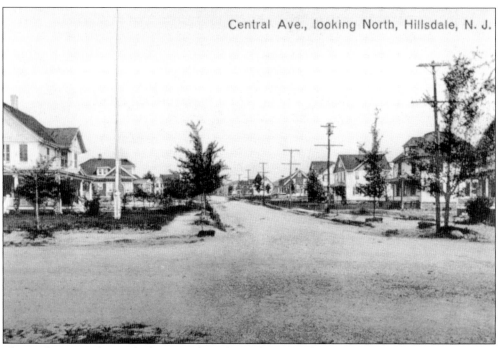

Central Ave., looking North, Hillsdale, N. J.

This early postcard view, looking north in the early 1900s, depicts Central Avenue. This would be the view if one was looking out from Fireman's Hall. (Courtesy George Jepson Estate.)

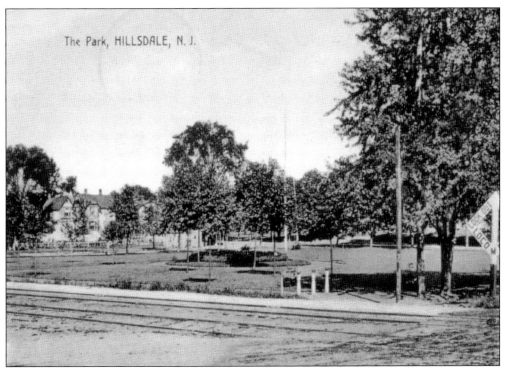

This postcard features the downtown park in the early 1900s. The park sites in downtown Hillsdale were donated to the citizens in 1871 by David P. Patterson. Memorial Park, as it was formally called, was swampy, and it took many wagon loads of ashes from the railyard to fill it. Also shown in this postcard is a railroad crossing sign that was installed in March 1909 for the Hillsdale Avenue crossing. In 1913, other crossing signs were installed on Park Avenue. (Courtesy Sean Smith.)

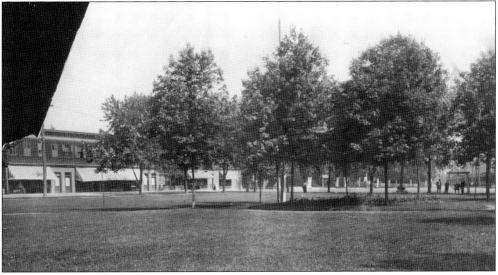

Pictured is a view of Memorial Park from Park Avenue. A public mass meeting was held at Manor House on April 7, 1900, that resulted in a petition being presented to the township committee authorizing it to spend the sum of $200 to improve the "Park plants, flowers and trees." (Courtesy Hillsdale Library.)

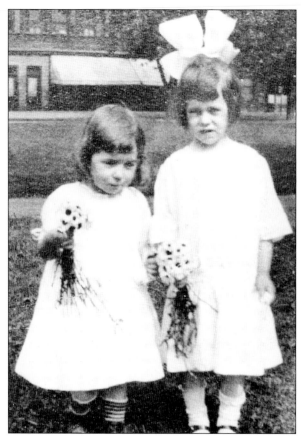

In 1916, two local girls hold bouquets they picked in Memorial Park. The Riley Building in the background. Infantile paralysis, or polio, was a frightening disease for many years, and it struck quite heavily in the summer of 1916. In Hillsdale, the health authorities stringently enforced the regulation of the state board of health, which required all children coming into Hillsdale must have a new and dated health certificate. The state directed that no child be allowed to pass from one municipality to another unless accompanied by a certificate from a health authority showing the date and hour upon which it was issued. (Courtesy Hillsdale Library.)

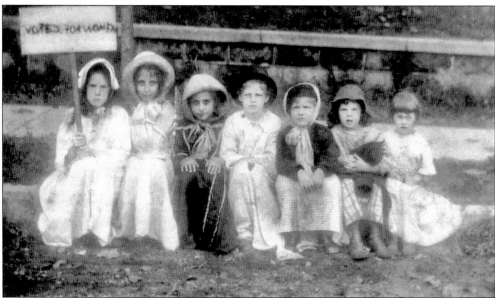

Pictured here are young girls parading for women's right to vote. The first public suffragist meeting was held on May 12, 1916, at Fireman's Hall. The hall was appropriately decorated in yellow, and the league's new banner was displayed for the first time. (Courtesy Sean Smith.)

Two

RAILROAD

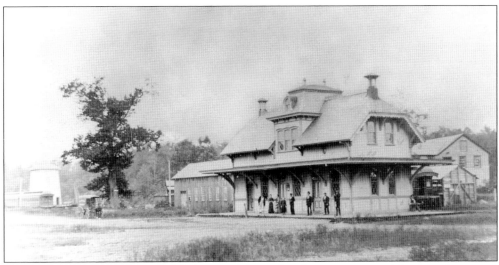

Shown here in 1885 is the Hillsdale Station. This railroad station is one of the most distinctive buildings on the former New Jersey & New York Railroad, a subsidiary of Erie Railroad. The Hackensack & New York Railroad built the station when it extended its line into New York state via the Hackensack and New York Extension Railroad Company. When the railroad was finished to Hillsdale in 1869, offices of the company were located on the second floor of the station and remained there for many years. There were complete facilities and an enginehouse located where Wendy's Restaurant is now. (Courtesy George Jepson Estate.)

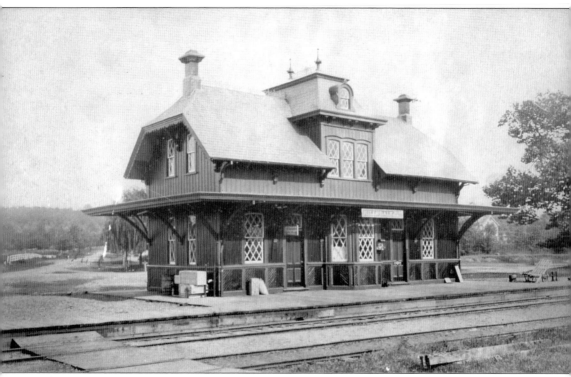

This late-1800s photograph of Hillsdale Station was taken looking east and shows where a door for the telegraph office was located. Hillsdale Avenue can be seen in the background with a white picket fence at the future site for the Riley Hotel. Beyond the fence was open fields as far as the eye could see. There were only six houses within a half mile radius of the station when the line was formally opened for public use on Saturday, March 4, 1870. Across the street, Summit Avenue (now Broadway) and Railroad Avenue, directly in front of the station, would have been the Hillsdale House that catered to the station. (Courtesy George Jepson Estate.)

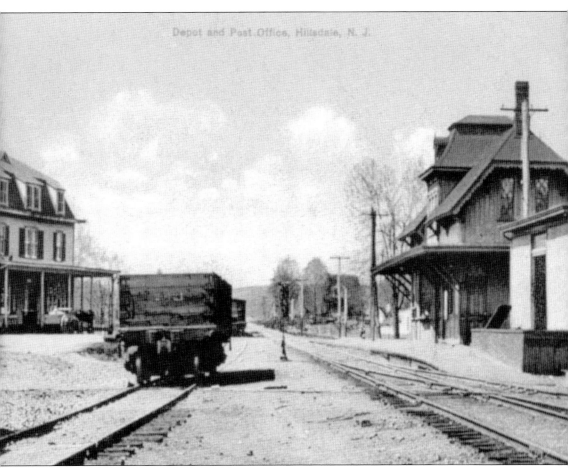

Depot and Post Office, Hillsdale, N. J.

This early 1900s postcard depicts the post office and train depot looking north. Across Hillsdale Avenue would have been Memorial Park, today known as Veterans Park. Although it would appear that no formal deed was ever given, a map in 1870 shows that the park sites in downtown Hillsdale were donated to the citizens by David P. Patterson, who was president of the New Jersey & New York Railroad. In 1895, Lena Patterson, David's widow, wished to recover the property, valued at $3,500. The case ultimately went to trial, and she did not prevail. (Courtesy Hillsdale Library.)

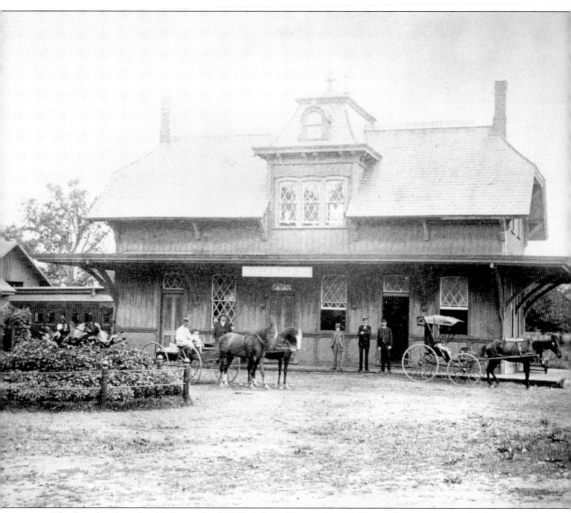

The local railroad, which reached Hillsdale in December 1869, was formally open for business on March 4, 1870. John Alfred Storms was the first station agent for the line, whose wood-burning locomotives, made in Paterson, continued in use until 1879. The first coal burner was sent over the rails in 1874 with the name "Hillsdale" painted on its side. (Courtesy Hillsdale Library.)

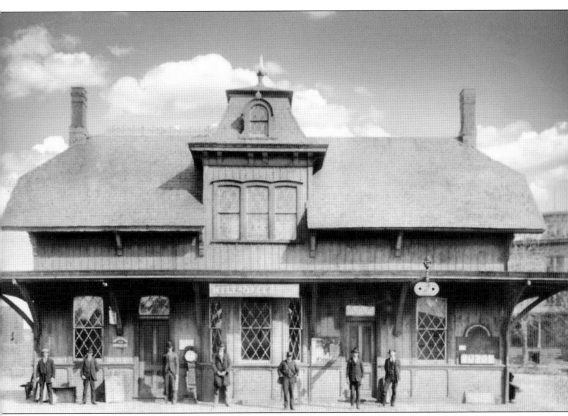

The Hillsdale Station was representative of the Second Empire style that was primarily characterized by a center tower on the front facade. The station had board and batten siding, diamond pane windows, and a steeply pitched roof with iron ridge cresting. The station was built by William H. Yeomans and Wallace Van Dorn, carpenters and builders of Pascack, now Woodcliff Lake, for the sum of $3,998. This site once had a wood-frame octagon outhouse with a cone-shaped roof and a wood-framed freight house that stood just south of the station. (Courtesy George Jepson Estate.)

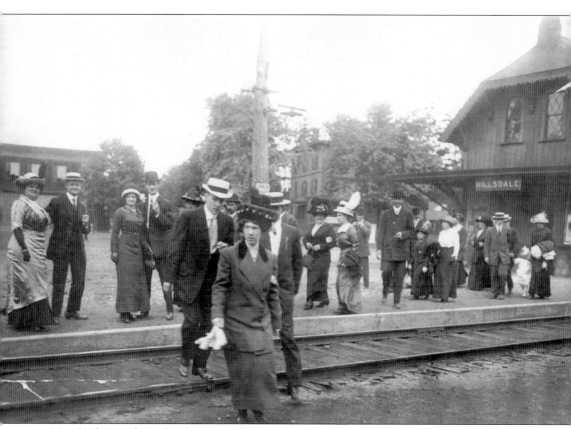

New Yorkers seeking the clear air and pastoral beauty of the country arrived at Hillsdale Station to stay at their summer cottages and villas in Glendale Park in the early 1900s. (Courtesy McSpirt family archive.)

New Jersey & N.Y.R.R.

This coupon of reduced fare ticket is valid only for one continuous passage from

PARK RIDGE to
HILLSDALE

on DAY OF SALE or within THIRTY DAYS next thereafter

Not Good if detached from ticket bearing Signature.

1912 5186

Regular Excursion

NEW JERSEY & NEW YORK
RAILROAD

THIS TICKET, AT A REDUCED FARE, IS VALID ONLY FOR ONE CONTINUOUS PASSAGE FROM

HILLSDALE to PARK RIDGE

On DAY OF SALE, or within THIRTY DAYS next thereafter.

The carriers' liability for baggage is limited to $100 for a full fare ticket and $50 for a half fare ticket, unless a greater value is declared by the at the time the baggage is checked and excess charges paid thereon.

5186 2

General Passenger Agent

Pictured above is a 1912 coupon to travel on the steam train from Hillsdale to Park Ridge. (Courtesy Pascack Historical Society.)

25

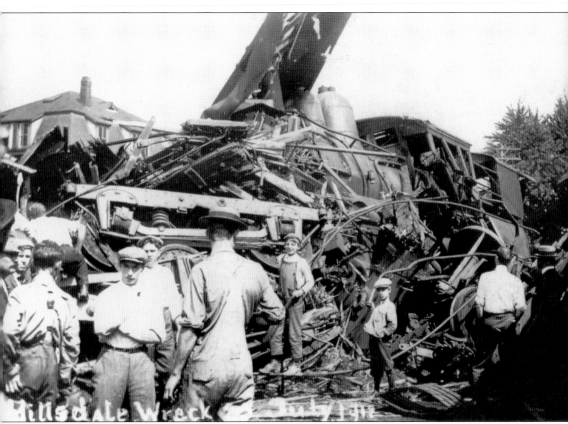

Hillsdale Wreck — July 1911

On the morning of July 1, 1912, a commuter train was being prepared at Hillsdale Station. Passengers were waiting to board when a freight train came barreling down the tracks. Seeing the commuter train, the engineer threw on the brakes; however, it was going too fast to stop. Luckily, both trains were empty at the time of the crash, and no one was hurt. (Courtesy Hillsdale Library.)

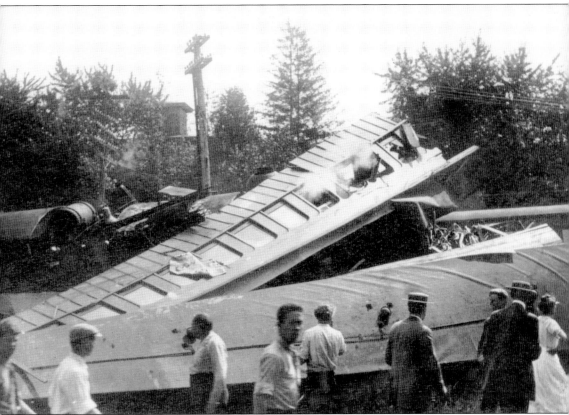

The three-car freight train was bound for Hackensack carrying new iron rails when it crashed. Fire companies from Westwood and an auto chemical engine from Park Ridge came down to assist local firemen when the pile of rubble caught fire. False reports spread along the line that several commuters had been killed in the accident, bringing about a feeling of uneasiness among riders. Rumors were soon corrected, however. According to customers at Winter's General Store, they reported grocery items spilling off the shelves as the building shook, and a nearby farmer said his animals had been so frightened by the wreck, his chickens refused to lay eggs for several days. (Courtesy Hillsdale Library.)

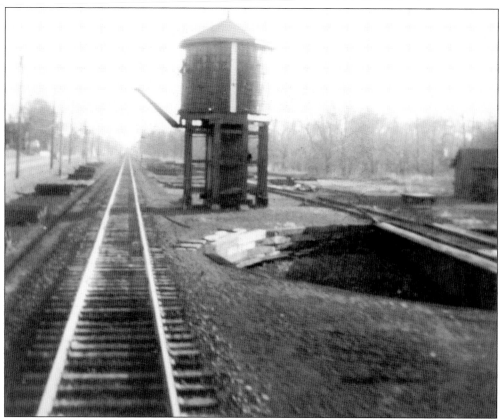

This 1936 photograph shows the water tower with a turntable just in front of it. Note the second set of train tracks as well. This site also had a large freight yard for storing trains and passenger coaches overnight and on weekends. The turntable where locomotives were turned was hand powered. The tank rarely ran dry, and if it did, the fire department pumper would be called to replenish it. (Both, courtesy George Jepson Estate.)

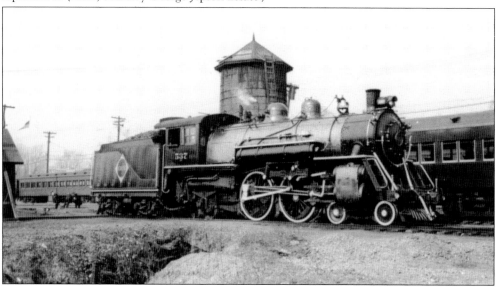

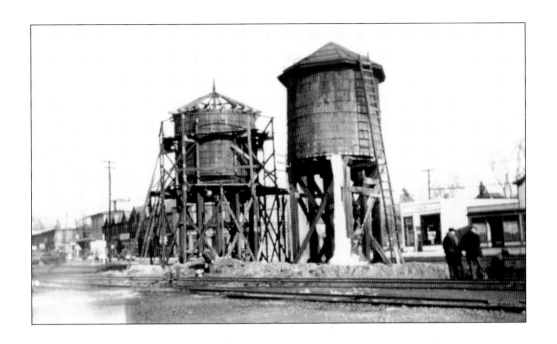

In the 1940s, the station got a new water tower. The "new" tower was eventually torn down, signifying the end of the steam locomotive era. (Both, courtesy George Jepson Estate.)

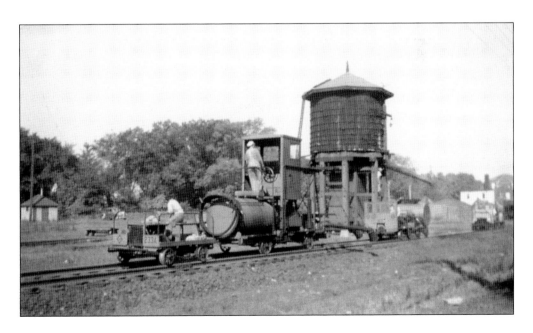

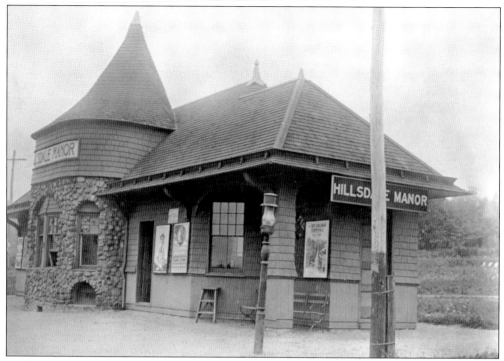

Unlike other stations on the New Jersey & New York Railroad, Hillsdale Manor was built in 1893 to serve the Manor Development Company, an area being developed by a New York real estate firm. This was promoted through advertising and special excursion trains. (Courtesy Peter Hard.)

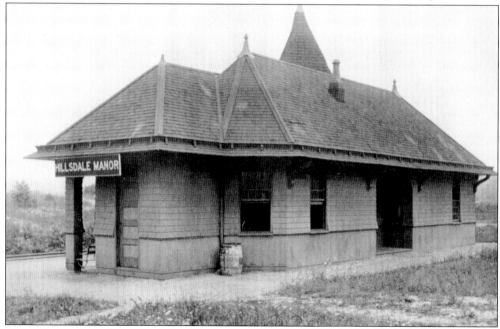

Hillsdale was the only town north of Hackensack to have two depot stops. The first train stopped on June 4, 1894. The train station lasted for almost 50 years before being torn down. (Courtesy Peter Hard.)

Manor Hotel was erected at the same time directly across the street from the train station. This cobblestone building provided accommodations to potential prospects, which later made the convenience of the railroad depot inevitable. Hillsdale Manor, which began as Hillsdale Terrace in January 1890, became the second major development in the township. (Courtesy Hillsdale Library.)

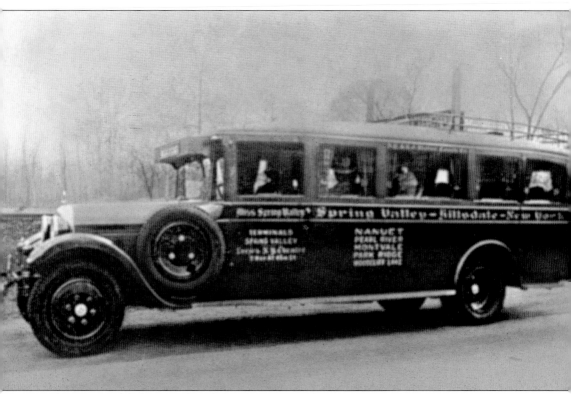

This 1925 Studebaker President deluxe bus operated between Spring Valley, New York, and Jersey City through Hillsdale for several years beginning in 1926. (Courtesy George Jepson Estate.)

Three

HOMES AND FARMS

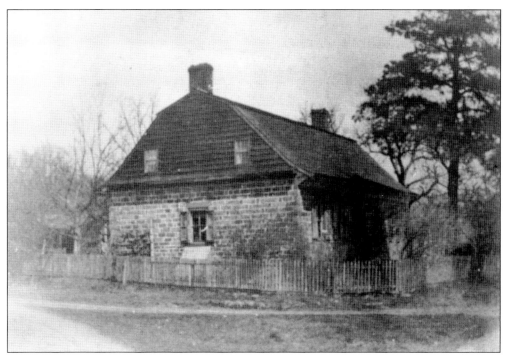

The Banta-MacArthur House, located at 211 Pascack Road, was built around 1749. This Dutch Colonial farmhouse sat on what was once the 400-acre farm of John Banta. This home appears on a Revolutionary War period map. (Courtesy Hillsdale Library.)

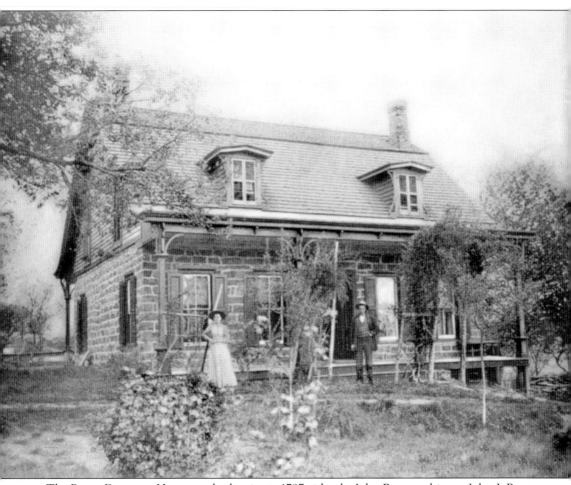

The Banta-Demarest House was built prior to 1797 either by John Banta or his son John I. Banta. The home was on the east side of Pascack Road where the current Lutheran church is located today. (Courtesy Hillsdale Library.)

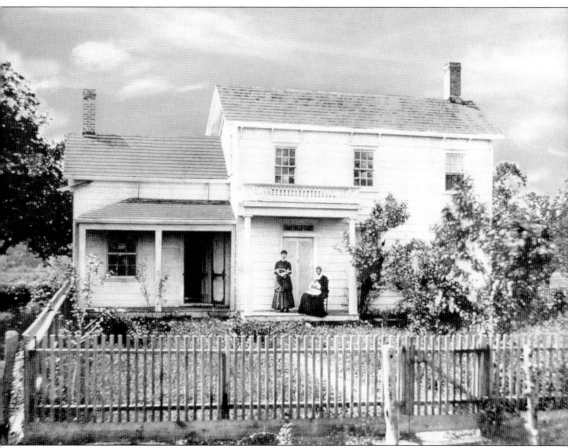

The Bachman House, located at 185 Piermont Avenue, was erected in 1853. This home has a place in African American history in Bergen County. Garret F. Haring of River Vale made his will after the death of his wife on August 31, 1836. He bestowed to his employee Sam, a former slave, the four acres of land on the south side of present Piermont Avenue, together with the sum of $100. (Courtesy Pascack Historical Society.)

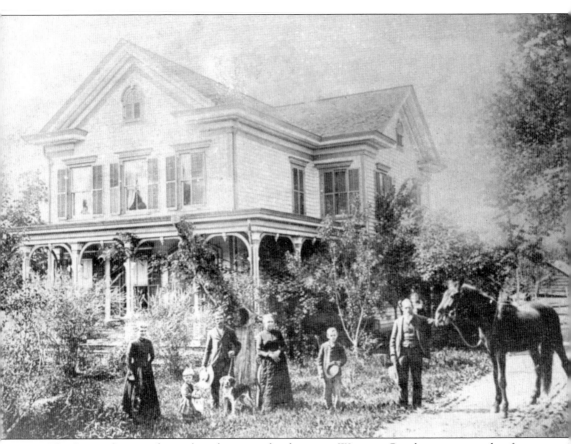

The Storms farm was located on the west side of town on Wierimus Road, near many other farms. Pictured are, from left to right, Nina (Peterson) Storms, Lavina Storms (holding doll), Albert H. Storms, Alletta Lavina (Zabriskie) Storms (1832–1892), an unidentified boy (holding hat), and Albert C. Storms (1834–1896.) (Courtesy Hillsdale Library.)

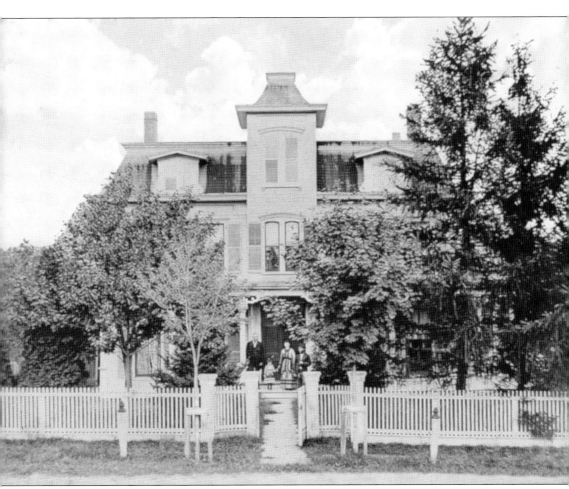

The Trall House, located at 520 Hillsdale Avenue, was built around 1875 and embellished with Gothic Revival vergeboards and king post gable trim. This Second Empire home was built on a 26-acre farm in the 1860s by Selden Trall, a retired druggist from New York. It was inherited by his son Orrin Trall, one of Hillsdale's founding fathers, a founding fire department member, a farmer, and the town and county tax collector. The home passed to Orrin's daughter Myra in 1924. She was married to George Yates, the first borough clerk and the third mayor of Hillsdale. At that time, the property contained a tennis court. (Courtesy Pascack Historical Society.)

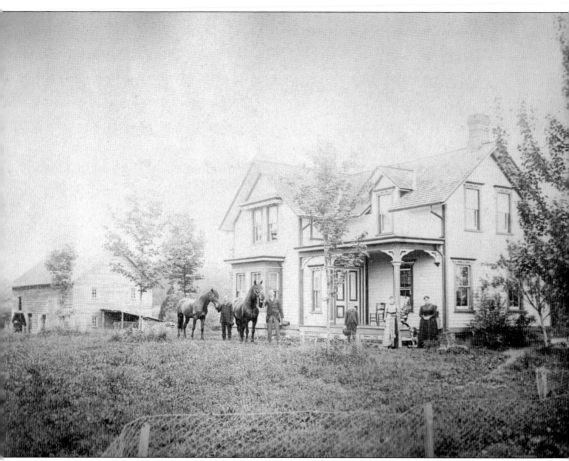

The Myers farm was located at the corner of Wierimus Road, west of Van Emburgh Avenue, which is currently west of Craig Road. Built in 1857, the farm was occupied by three generations of the Myers family. The house was built on a pre-revolutionary stone foundation against an addition that was left standing. Jacob Myers and his son Franklin J. Meyer were local businessmen and served on the zoning board of adjustment in Hillsdale. This photograph depicts the family in 1890. (Courtesy Hillsdale Library.)

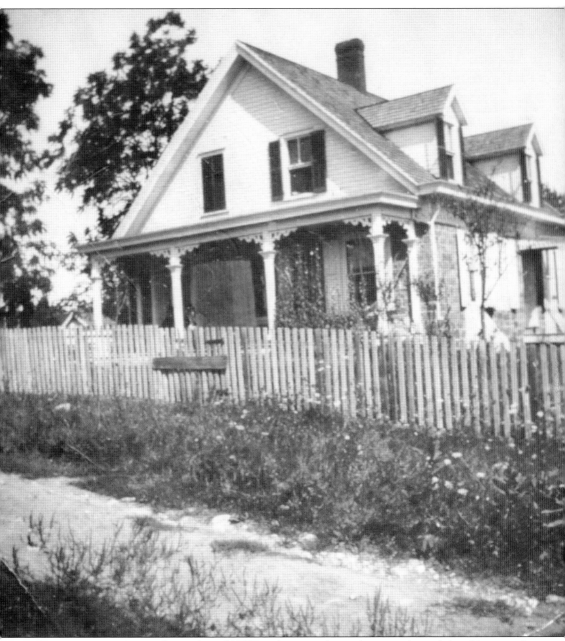

The Garret Durie House, located at 156 Ell Road, is a sandstone home with much local historical significance due to its association with Garret Durie, a farmer and blacksmith, who was also a Bergen County freeholder and judge. Built in 1767, the house was taken in the Revolutionary War by both American and British soldiers. (Courtesy Hillsdale Library.)

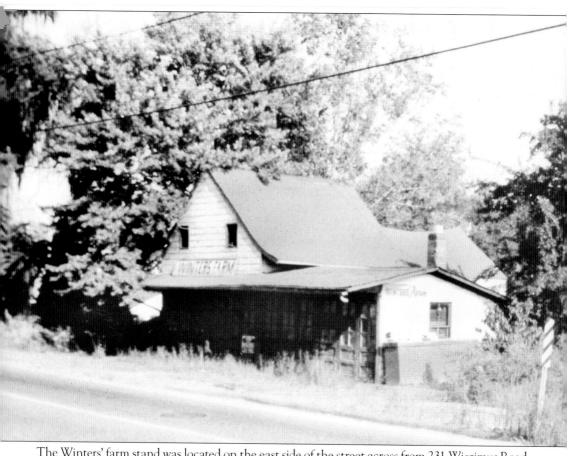

The Winters' farm stand was located on the east side of the street across from 231 Wierimus Road, where the Bogert House stood. The Winters family traveled several times a week to the New York Market to sell their produce. (Courtesy Frank Maniaci.)

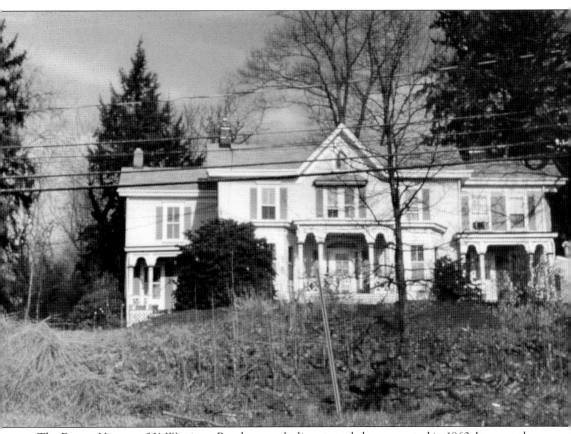

The Bogert House at 231 Wierimus Road was an Italianate-style home erected in 1860. It currently overlooks the Garden State Parkway, which prior to the 1950s was lush farmland. This area was once the homestead of Winters Farm. (Courtesy Hillsdale Library.)

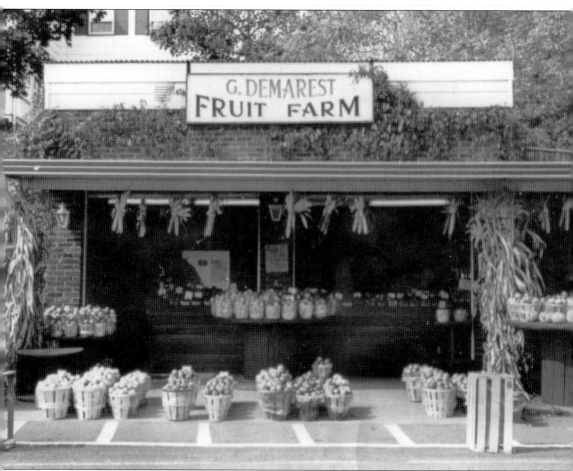

The G. Demarest Fruit Farm stand was located at 244 Wierimus Road. One of Hillsdale's most thriving businesses today, it was started in 1856 when George Washington Demarest purchased 40 acres of land in Hillsdale and Saddle River. The farm has been passed down to four generations and is now owned by Jason DeGise and Jim Spollen, who both started working at the farm as teenagers. The farm is a link between the present and Hillsdale's early history when farms dominated the landscape. (Courtesy Pascack Historical Society.)

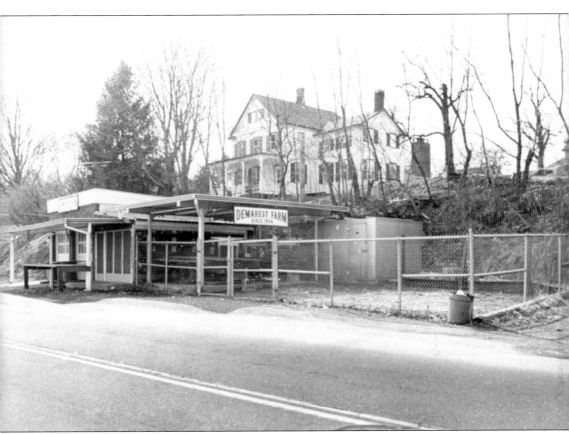

The Demarest farm stand and farmhouse overlook the Garden State Parkway. This home was built before 1800. From the Vanderbeek family it went to the Van Ripers and was then sold to George W. Demarest. Demarest sold most of the farm's produce to regular customers in Ridgewood, New Jersey. (Courtesy Hillsdale Library.)

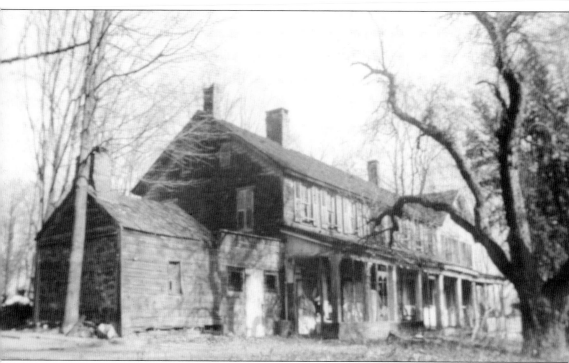

The Clendenny farmhouse was originally purchased in 1837 by Andried Smith with 102 acres. The farm grew to 500 acres by the time the last owner, Smith's great-grandson, Henry Clendenny, came to possess the land. The earliest known owner and occupant of the Clendenny House was Johannes Myer, who lived there around the middle of the 18th century. He may have built the original house, but no records have been located to substantiate this or an exact date. Like the usual style of that period, the modest-sized house started out with two rooms and a garret, each room having an outside door in front and a fireplace on the ends. The earliest records found bearing the name of Johannes Myer is the surveyor's return involving Pascack Road and Hillsdale Avenue, when the courses of an older route were altered in May 1759. This was, and had been for a number of years, the old and original Pascack Road, which ran easterly as far as Yesler Way, then southerly into present-day Westwood, and to the Bogert Mill, near the pond. The Myer farm contained over 100 acres and extended along the north side of Hillsdale Avenue from the Pascack Brook west to Pascack Road and then along the latter near Wierimus Lane. In the 1760s, Johannes Myer sold his farm. Part of the land at the northwest corner was acquired by a neighbor, John Banta, whose homestead was the present-day Banta-MacArthur House. (Courtesy Pascack Historical Society.)

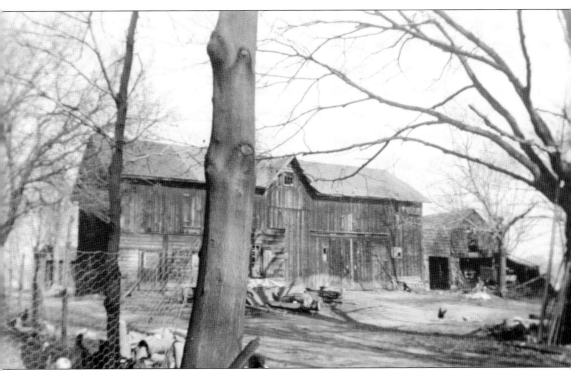

This photograph shows Henry Clendenny's barns. The main barn, on the west side of the driveway, contained four or five stalls and an area where hay, feed, and equipment were kept. A smaller attached barn with rabbit coops ran south of the main barn. The chicken coops lined the north side of the property, along the border of Windham Road. Clendenny had been nicknamed Hillsdale's "Dr. Doolittle" by town's children, who often received rides on his horse-drawn wagons and would regularly visit the farm. The hayrides took place at night, with the hay wagon loading and unloading on Windham Road. What a beautiful sight it was to see the hay wagon all lit up! Children would join him on these rides, riding high up in the driver's seat by his side as he maneuvered the team down Hillsdale Avenue, left onto Broadway, and north to Woodcliff Lake. Clendenny guided the horses, firm hands on the reins, calling out directions to each horse by name. (Courtesy Pascack Historical Society.)

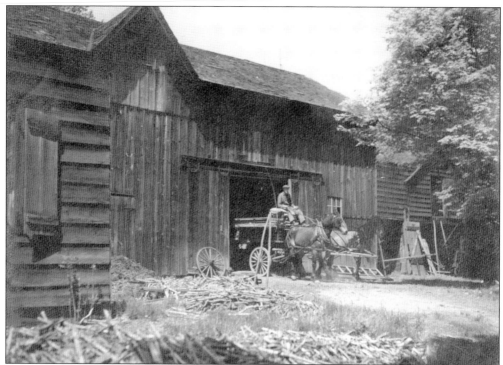

A boy walks his dog on the Clendenny farm. It was common for children to purchase strawberries and milk from the farm while visiting Clendenny's animals. His farm was a menagerie of animals, including horses, roosters, hens, rabbits, an ancient pony, and, of course, his beloved dogs and cats. The Windham Road neighborhood awakened each morning to the sound of a rooster crowing. Depending on the year, it was either Red the rooster or Whitey the rooster. Red the rooster was renowned. He guarded the property and was known to run a person off, wings spread, as he gave chase. (Both, courtesy Pascack Historical Society.)

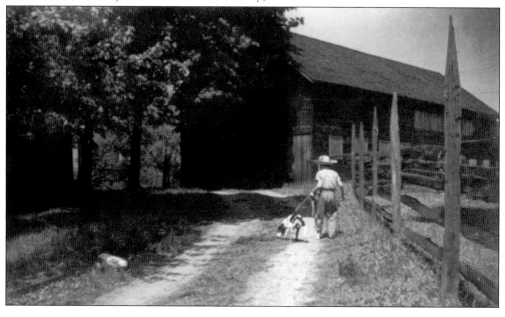

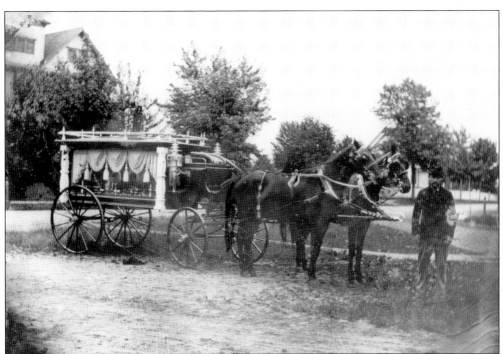

The Clendennys were well-to-do landowners who also operated the first funeral home in Hillsdale. Henry Clendenny's undertaking service was known for his custom-made coffins that followed the contours of the deceased. The horse-drawn hearse was kept in the barn in the back of the property. The Reverend Decker referenced on the receipt at left is Ellsworth W. Decker. He is listed as "Clergyman" in the 1915 New Jersey census, living in Westwood. (Both, courtesy Pascack Historical Society.)

WESTWOOD, N. J., Jan 30, 1914

M Estate of Anthony Duppenburg

To CLARENCE VREELAND, Dr.

Funeral Director and Furnishing Undertaker

COACHES AND CAMP CHAIRS TO HIRE

Telephone 13 R. Burial of Anthony Duppenburg THIRD AVENUE

Wagon and team from Westwood to Hortendyke	10	00	
Fine solid oak casket, silver extension handles & name plate trimmings and satin lining			
Polished chestnut box and box trimming	125	00	
Black burial suit	5	00	
Embalming body	10	00	
Shaving body	3	00	
Hearse & team to Park Ridge cemetary	10	00	
One coach to Park Ridge cemetary	6	00	
Advertisement in "Paterson Call"		80	
Opening grave	6	00	
Opening church	2	00	
Rev Decker	2	00	
		179	80

47

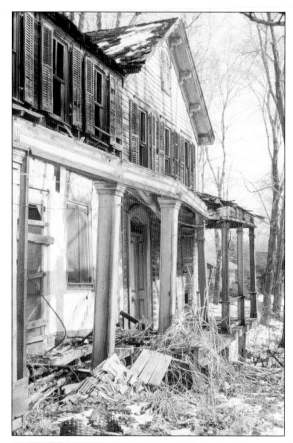

Over the years and through financial misfortunes, the Clendenny farmland was sold or lost to back taxes bit by bit and ended with demolition of the house in 1969. (The Clendenny home had been abandoned by 1968.) It was in poor condition, and even visionaries agreed it was not feasible to restore to its original condition. The farmland now makes up the Tandy and Allen development on the west side of town. (Both, courtesy Frank Maniaci.)

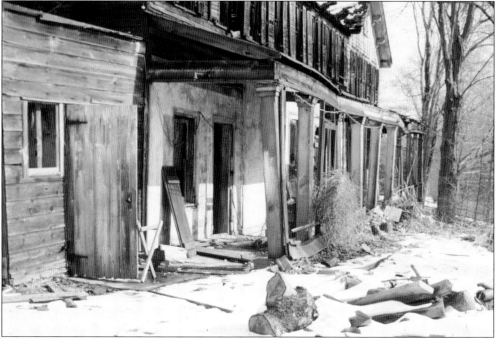

Four

CHURCHES

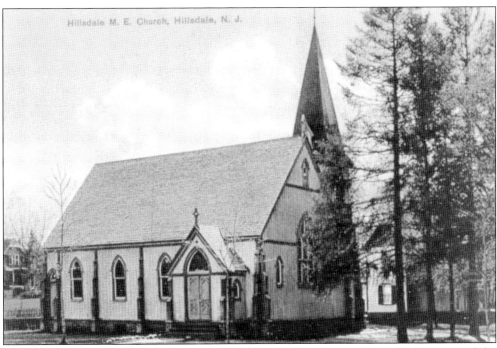

The Methodist Episcopal Church was organized on May 3, 1874, by Reverend J. Switzer, and the church was built in 1876 on land donated by David P. Patterson. The Methodist church had the honor of being the first erected church in the village and held its first service in 1876. (Courtesy Hillsdale Library.)

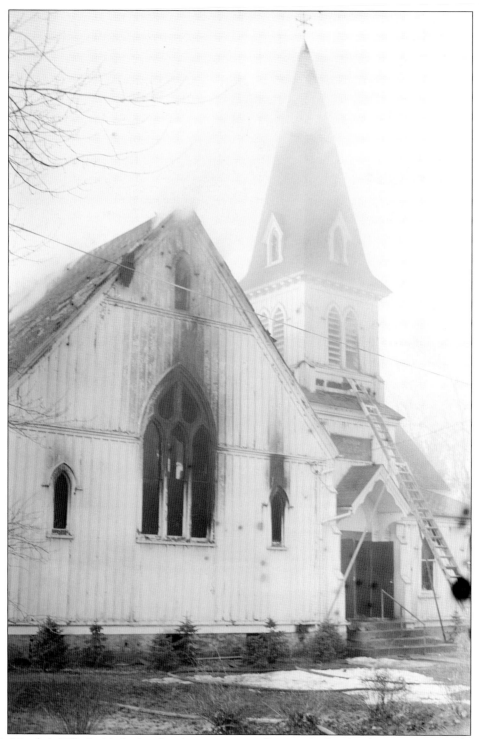

On March 4, 1961, the Methodist church was intentionally set on fire by a local arsonist, Ken Brigham. It was suspected that Brigham was responsible for a fire set at the Marsala Hardware warehouse, but he was only charged with the church fire. (Courtesy Hillsdale Fire Department Archives.)

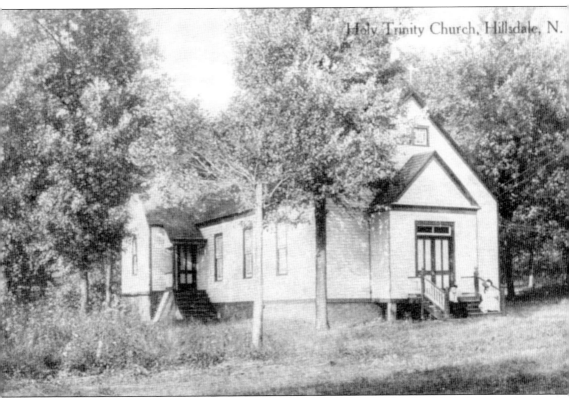

Holy Trinity Mission's first church building was located on the north side of Park Avenue. On May 21, 1890, a lot was acquired east of the railroad by a deed from Ellen Patterson, and the first sanctuary was built. Holy Trinity Mission was organized in 1889. The first service was held by the Reverend Thomas Stevens on January 29, 1890, in the residence of J.C. Fincke. Subsequent services were held on the second floor of the railroad station in Hillsdale. (Courtesy George Jepson Estate.)

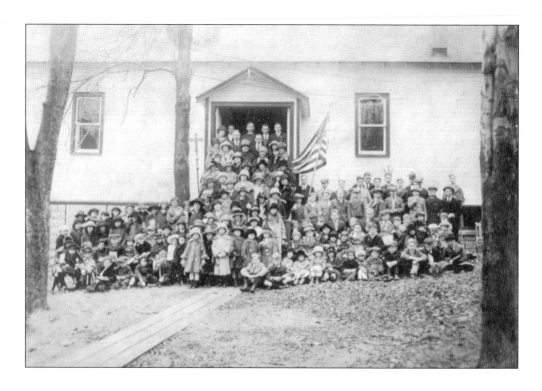

Holy Trinity Episcopal Church moved to its present location on Hillsdale Avenue in March 1894 on land donated by Mrs. A.C. Holdrum of River Vale. The church was later remodeled into its present structure. Holy Trinity became a parish in May 1945. Rev. Richard Aselford became the first rector. (Both, courtesy Hillsdale Library.)

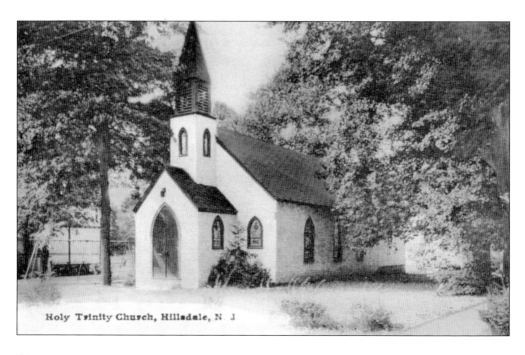

Holy Trinity Church, Hillsdale, N. J.

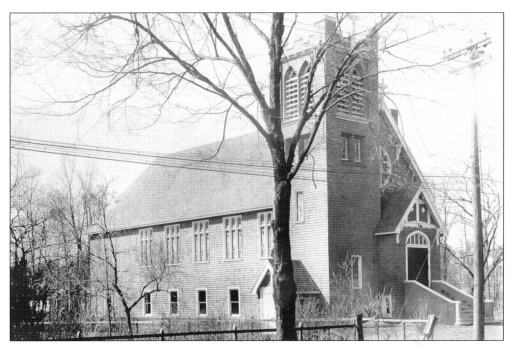

In 1925, a group of Catholics had a desire to build a church in Hillsdale. Around this time, the Ku Klux Klan (KKK) was active in the area, and there were documented cross burnings. On one occasion, on Cedar Lane in Rivervale, three white-sheeted hooded men threatened to run a resident out of town if he tried to build the Catholic church. The KKK warned Helen Riley not to sell her property to Catholic men, so she donated it to them. Ground was broken on April 4, 1925, and the church was dedicated on December 15, 1925. (Courtesy Hillsdale Library.)

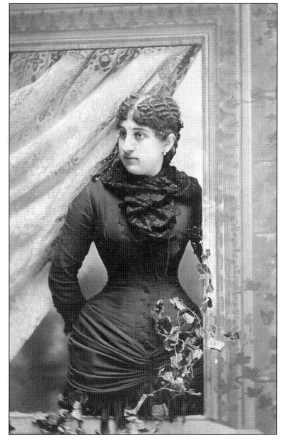

Pictured here is Helen Riley, the wife of John Riley. A meeting of approximately 28 families was held at the Riley house on Hillsdale Avenue to plan the new church. These original members pledged and donated money. One member, Louise Meyer, came with five $10 gold pieces. Helen Riley decided she would donate the land for the church. Lawn parties were held on the Riley's property to raise money for the church. (Courtesy Hillsdale Library.)

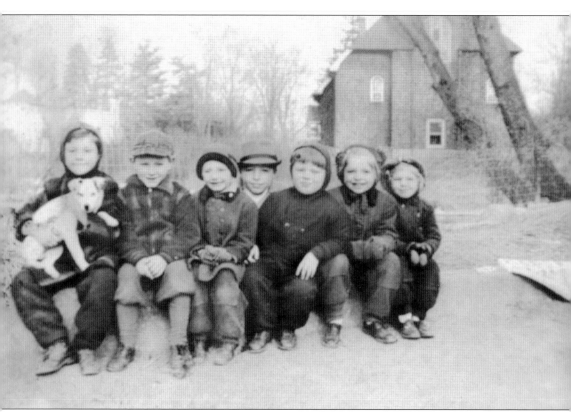

Glendale Park children pose for a photograph in the 1930s. In the background is the rear of St. John's church. Glendale Park began its development between the turn of the 20th century and 1910, when the Crest Development Company opened up land from Taylor Street east to Summit Avenue, including the Boulevard and Crest Road. (Courtesy McSpirt family archives.)

Five

SCHOOLS

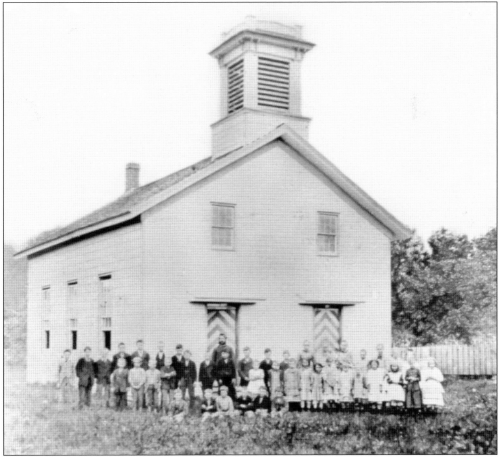

Hillsdale's first school was located on Pascack Road just south of Hillsdale Avenue. The schoolhouse was built in 1856. It contained one large, open room that housed students from kindergarten through eighth grade. W.W. Banta was the first principal of the school as well as one of its teachers. In 1856, there were 36 pupils enrolled. When the town seceded from Washington Township, it took the Hillsdale name from the school and the train station. This photograph is dated 1873. (Courtesy Hillsdale Library.)

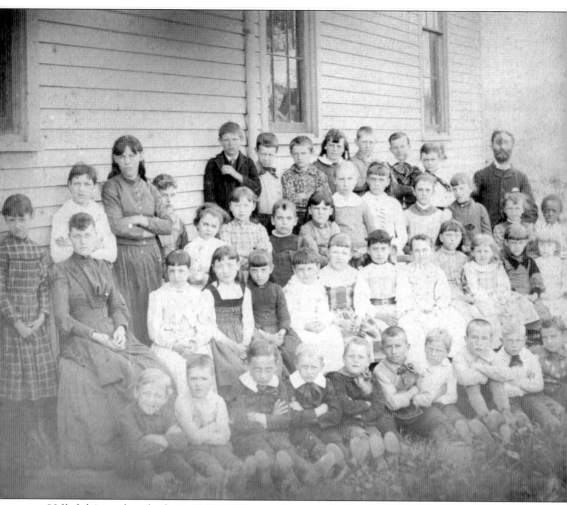

Hillsdale's student body in 1887–1888 was photographed at the Hillsdale School on Pascack Road. The Hillsdale Board of Education was organized on April 23, 1898, with A.C. Holdrum as president and William Blauvelt as clerk. (Courtesy George Jepson Estate.)

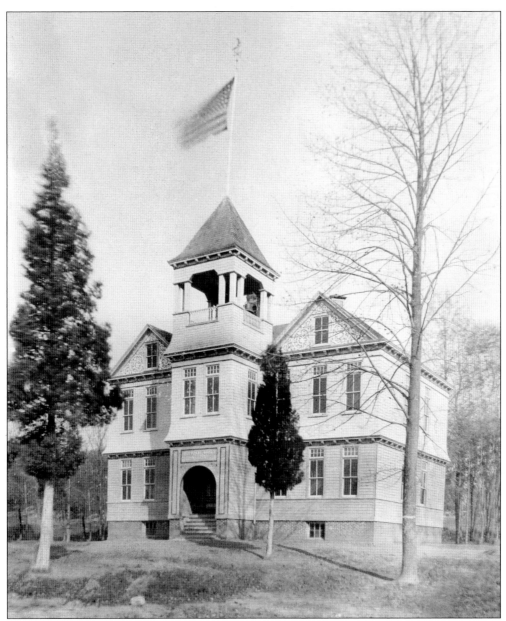

When a new school was constructed on Magnolia Avenue in 1892, pupils attending the old school on Pascack Road transferred to the two-story, four-room building, complete with a belfry over the front entrance. It was built by Ralph Durie of Old Tappan for the price of $3,450. The north side of the building provided drinking water. A student's pencil box at that time usually contained a collapsible tin drinking cup. There was no indoor plumbing, and the amenities were located some distance in the rear of the schoolyard. Each Arbor Day in April was an occasion for beautifying these facilities by planting camouflaging trees and shrubs. (Courtesy Hillsdale Library.)

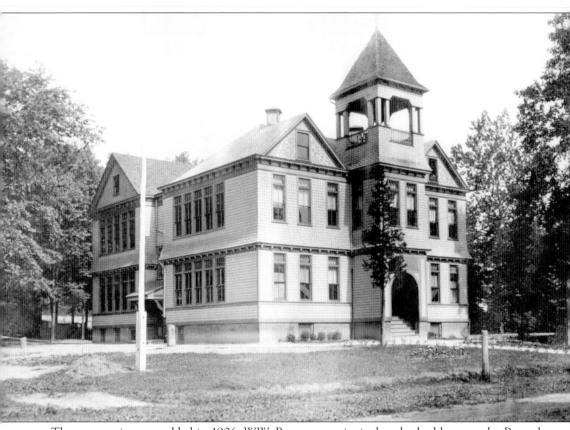

The rear section was added in 1906. W.W. Banta was principal, as he had been at the Pascack Road school. He also taught eighth grade and prepared students for algebra in high school. Many graduates went on to Park Ridge High School. Born in 1857, Banta retired in 1920. (Courtesy George Jepson Estate.)

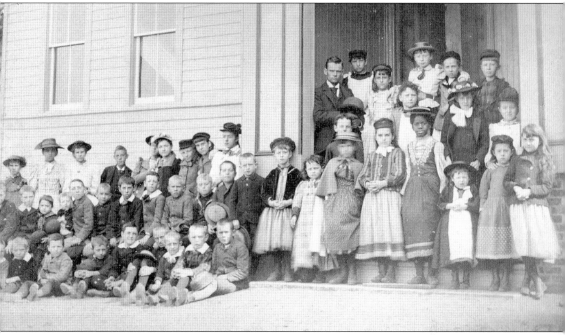

The student body is pictured here in 1890 outside of Hillsdale's four-room wooden schoolhouse. Graduation ceremonies were held in the old firehouse. Lower-class members were set to the task of gathering daisies from the field across from the school, which were placed in buckets across the front stage. (Courtesy Hillsdale Library.)

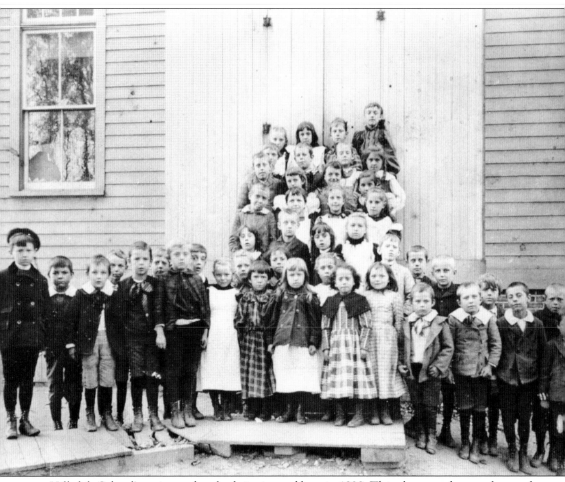

Hillsdale School's entire student body is pictured here in 1898. This photograph was taken at the back door of the second Hillsdale grammar school on Magnolia Avenue. In 1898, there would have been woods in the back of the school to the east and a narrow valley on the south side. A ballpark occupied the north side. (Courtesy Hillsdale Library.)

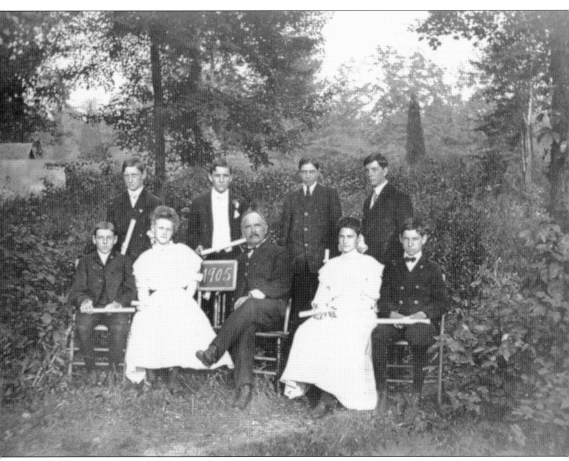

Hillsdale students were photographed in the vacant lot at the southeast rear of the four-room school in 1905. W.W. Banta, principal and teacher of seventh and eighth grades, is seen at center. By 1906, the schoolhouse had been enlarged to eight rooms. (Courtesy Hillsdale Library.)

Pictured is a Hillsdale student play in the eight-room schoolhouse. The year is unknown. According to accounts, the wooden schoolhouse smelled of varnish and oiled floors. (Both, courtesy George Jepson Estate.)

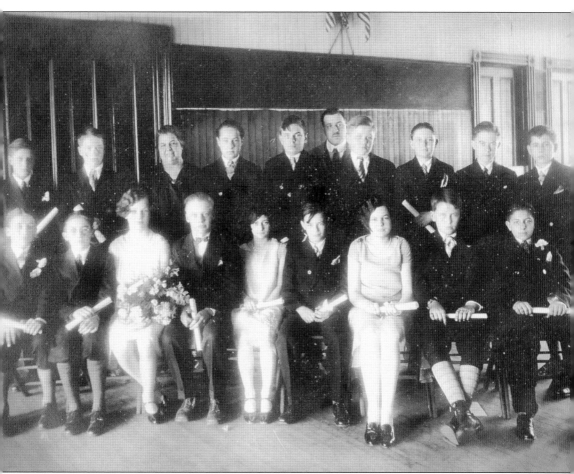

The student body in 1926 is shown above with teacher George W. White. It was rumored that White did not like his photograph taken. There are only two known photographs of Principal White, who lived on Magnolia Avenue. (Courtesy George Jepson Estate.)

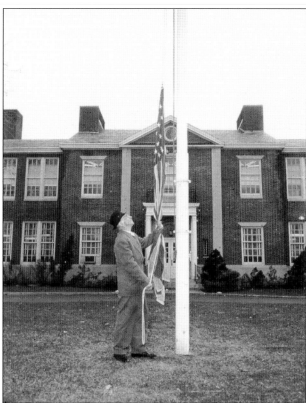

The school janitor, William "Pops" Bulach, father of a former police chief, William Bulach Jr., raises the flag at George White Middle School, built in 1921. (Courtesy Al Achinson archives.)

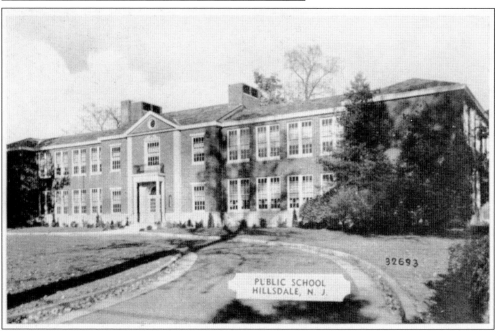

George White Middle School, built on Magnolia Avenue, is shown here around the 1940s. The building consisted of 10 classrooms and an auditorium. It was enlarged in 1938 with six classrooms and an auditorium. The school athletic field was acquired in 1924. (Courtesy Hillsdale Library.)

Six

BUSINESSES

Pictured at the turn of the 20th century is downtown Hillsdale with the Hillsdale House at left. Built around 1871, it later became the Werkheiser Hotel and Smith's department store. At right, the railroad facilities included a turntable, roundhouse, water tower, and six sidings on which between 50 to 60 coaches and five steam locomotives were stored. (Courtesy George Jepson Estate.)

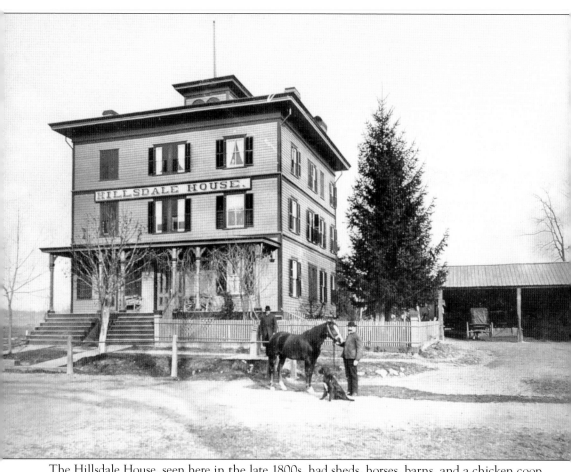

The Hillsdale House, seen here in the late 1800s, had sheds, horses, barns, and a chicken coop out back. There was a large field where cattle would graze. (Courtesy Hillsdale Library.)

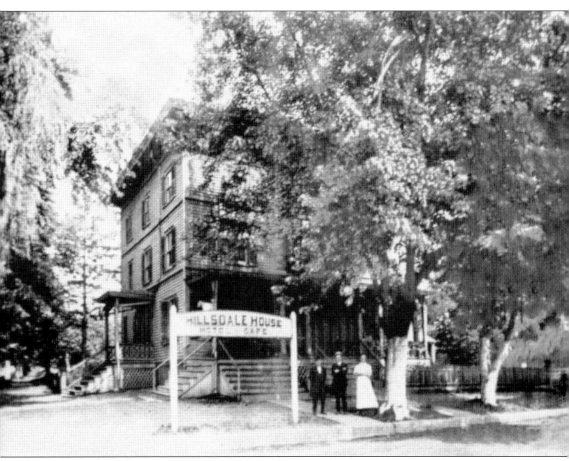

This 1918 view of the Hillsdale House Hotel Café was taken from the southeast corner of Hillsdale Avenue. The hotel had chickens for fresh eggs, cows for milk, meat, butter, and geese for holiday treats. Hungry and thirsty patrons were greeted by Mrs. Werkheiser and her husband, Reeves. (Courtesy Pascack Historical Society.)

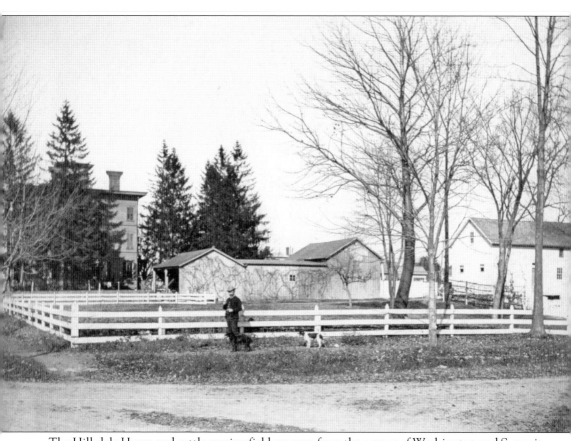

The Hillsdale House and cattle grazing field are seen from the corner of Washington and Summit Avenues. Reeves Werkheiser and his dog are shown in the foreground. (Courtesy Hillsdale Library.)

This is an early 1900s view of Washington and Summit Avenues. In the rainy season, Summit Avenue became a muddy mess. Many early cars sank into the mud and had to be pulled out with horses. Summit Avenue was paved with modern concrete just after World War I. It took almost a year to pave from Washington Avenue in Hillsdale to Irvington Street in Westwood. (Courtesy Hillsdale Library.)

This photograph shows the Hillsdale House garden located behind the hotel, now where the present borough east parking lot begins. Mrs. Werkheiser's mother, second from left, was the first

hotel owner. From left to right are Reeves Werkheiser, Mrs. Werkheiser, Mrs. Wortendyke, and Edward Krauder, the hotel's bartender. (Courtesy Hillsdale Library.)

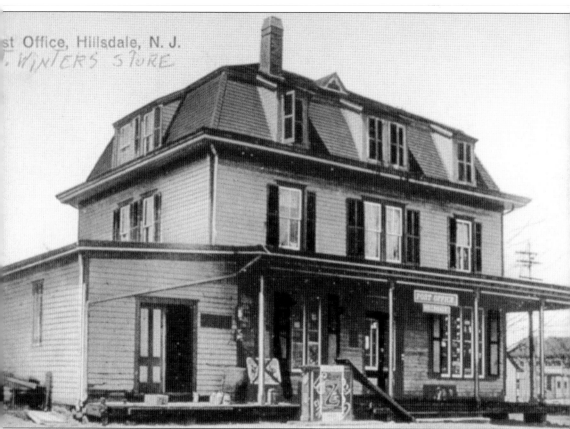

The post office is pictured here in 1898. That year, the post office moved into the Leddy Building next to Hillsdale Station. Prior to that, it was located at 148 Broadway. The Leddy Building was owned by John F. Winters, who was also the postmaster at the time. Prior to 1870, Hillsdale residents received mail once a week and had to call for it at the tavern in Pascack, now Woodcliff Lake. With the arrival of the railroad in 1870, mail was able to be received daily. (Courtesy George Jepson Archives.)

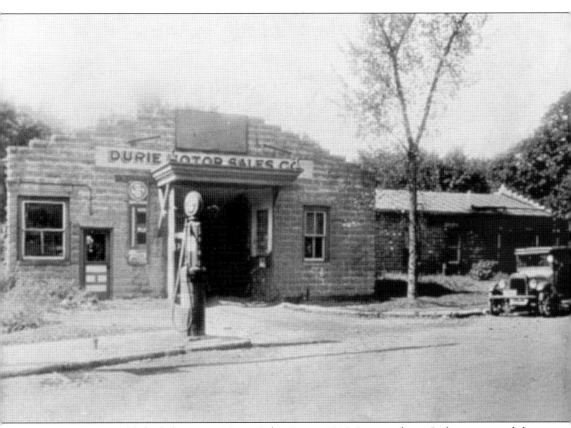

Ira Durie Sr. established the Durie Motor Sales Co. in 1909. It started as a Jackson automobile dealership and then became a Studebaker distributor. The business eventually moved to Broadway at the intersection with Piermont Avenue. This building is now the Bergen County Garden Center, located on Winkler Way. (Courtesy Durie family archives.)

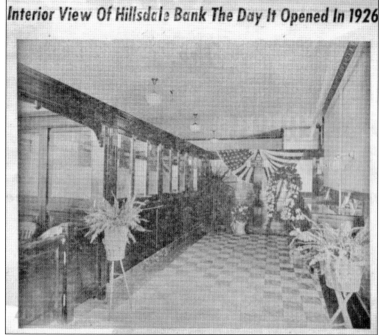

Interior View Of Hillsdale Bank The Day It Opened In 1926

The interior of the Hillsdale National Bank is shown here in 1926. Deposits at the close of the first day of business totaled $52,064.83 in 110 accounts. (Courtesy Hillsdale Library.)

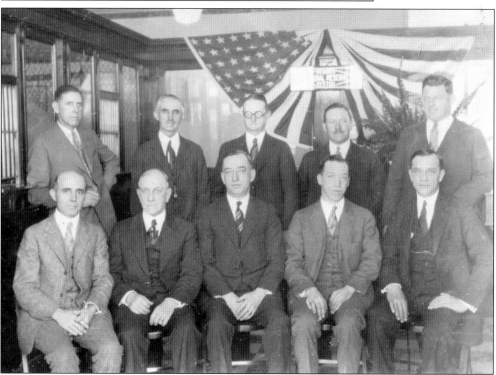

Pictured is the first board of the Hillsdale National Bank. Pictured in no particular order are John Buckley, Edward Davis, William W. Livengood, Charles A. Lorentz, Anton Maksche, Bernard F. Rafferty, John A. Schlotterbeck, Albert H. Storms, Henry J. Werner (Hillsdale's first mayor), and George M. Yates. (Courtesy Hillsdale Library.)

Lou's Tavern, where good friends have been meeting for over eight decades, is shown here in the 1930s. In June 1933, the Hillsdale Businessmen's Association organized. (Courtesy Peter Hard.)

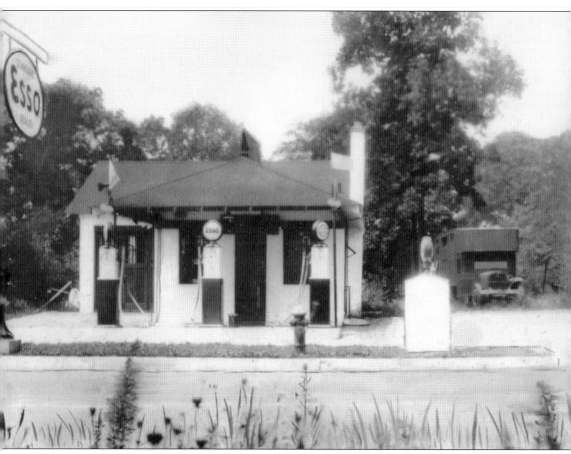

The Eastern Highway Service, an Esso station, was photographed in the 1930s. This station served the Manor Section and was located at 333 Kinderkamack Road, which was called Eastern Boulevard at the time. (Courtesy Fred Meyer.)

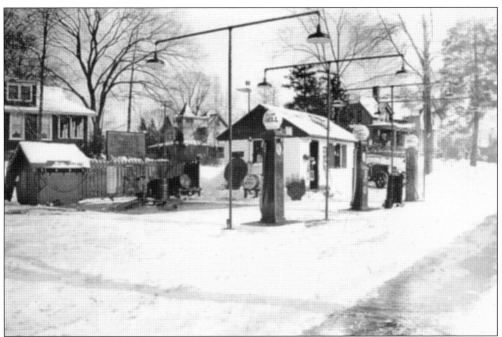

George Jepson's Shell Station, located at 60 Broadway, is pictured here in 1932. Jepson owned the station from 1932 to 1965. In 1932, gas prices were 16¢ a gallon. There was no super, no lead, and no mid-grade—just gas. Jepson performed domestic repairs, but his specialty was Packards and Fords. (Both, courtesy George Jepson Estate.)

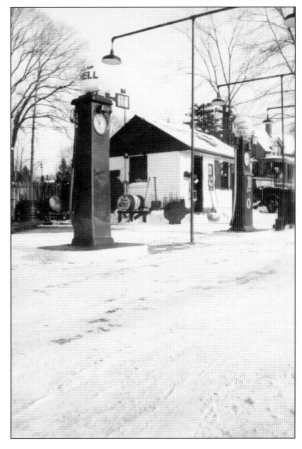

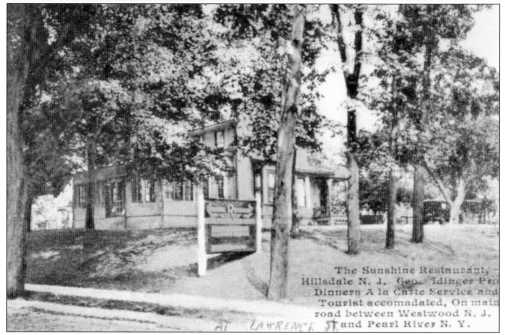

The Sunshine Restaurant, located at Broadway and Lawrence Street, was raided in 1930 under the direction of the police commissioner. Confiscated were 38 pints of ale and 14 pints of Old Overbrook Whiskey. (Courtesy George Jepson Estate.)

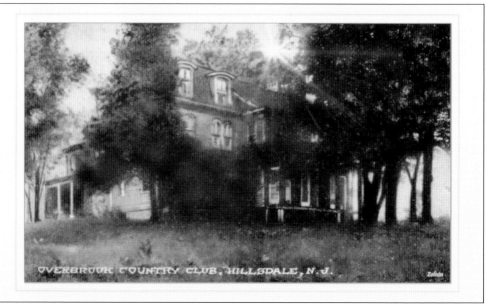

A major center of social life in Hillsdale was the Overbrook Country Club, located by Pascack Brook on present-day Carlyle Place. For more than 15 years the club thrived; there were parties, games, dancing, and bowling. However, the Great Depression was its downfall, and as those years loomed, membership began to decline in interest, and the club began to wane. On the night of August 7, 1931, fire broke out in the club. The fire was no accident, and the culprits were identified. (Courtesy George Jepson Estate.)

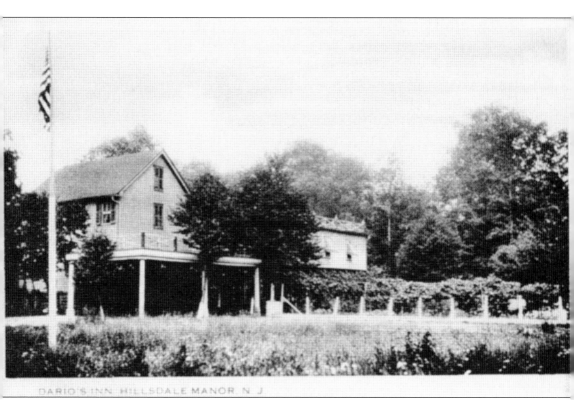

Dario's Inn on Clinton Avenue in Hillsdale Manor is shown above. This restaurant catered to the growing Manor population along with the Villa Cesare Restaurant. (Courtesy George Jepson Estate.)

The Famous Koenig's Hofbrau, Hillsdale, N. J.

Koenig's Hofbrau was a popular catering hall from the 1920s through the 1940s. This German restaurant featured swing bands every Saturday and Bavarian bands every Sunday and held most of Hillsdale's political events and police dances. In 1969, the building burned to the ground, and the fire was investigated as a possible arson. The venue was located where the Kings supermarket plaza is today. (Courtesy Hillsdale Library.)

Seven

RECREATION

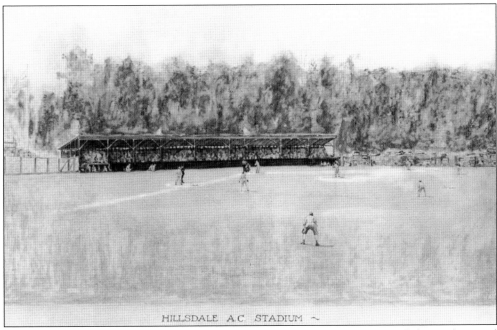

During the 1920s, Hillsdale Athletic Club Stadium exhibition games featured the Yankees and other major league teams. In 1939, the New York Black Yankees of the Negro League also played at the athletic club's field. A Hillsdale resident, Eugene Rich, a well-known baseball promoter, was the president of Hillsdale Athletic Club. (Courtesy George Jepson Estate.)

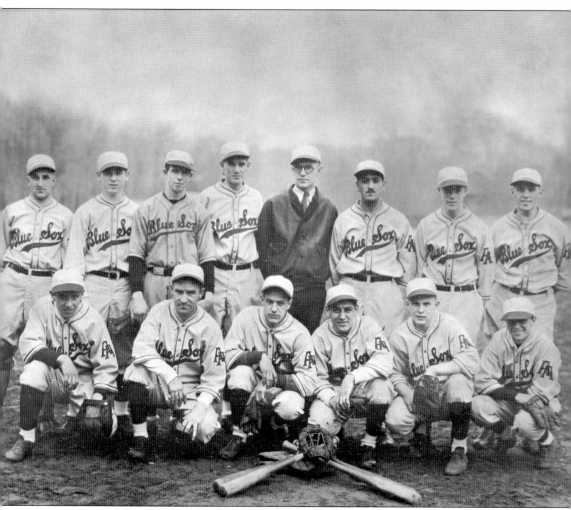

The Hillsdale Blue Sox are pictured here in 1929. Another team called Washington played Saturday ball on a huge ball field with a grandstand. It was located behind the Manor Station near a box factory. (Courtesy Hillsdale Recreation Department archives.)

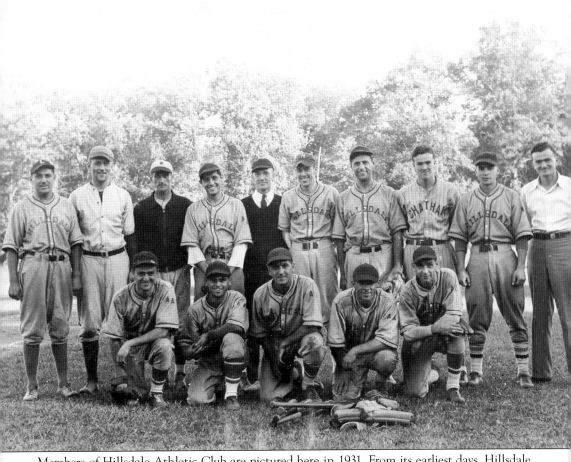

Members of Hillsdale Athletic Club are pictured here in 1931. From its earliest days, Hillsdale won a reputation as the home of outstanding athletic teams. The Hillsdale Athletic Club was known all over the county for its championship baseball teams. Later, the Hillsdale Saxons and teams sponsored by various business firms carried on the tradition of fielding winning teams. (Courtesy Hillsdale Recreation Department archives.)

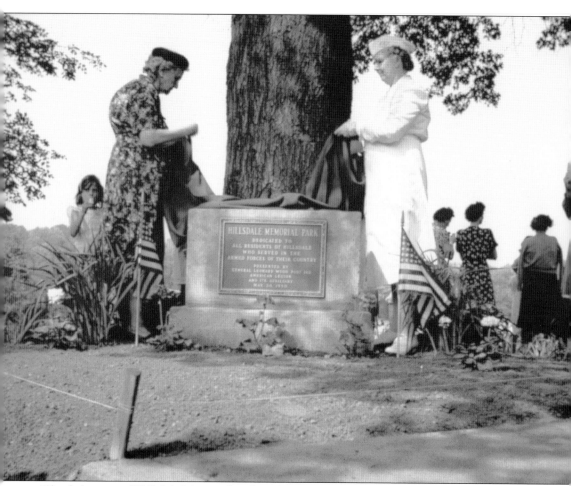

The dedication of Hillsdale Memorial Park took place on May 30, 1950. The field was dedicated to all residents of Hillsdale who served in the US armed forces. It was presented by General Leonard E. Wood American Legion Post 162. (Courtesy Pascack Historical Society.)

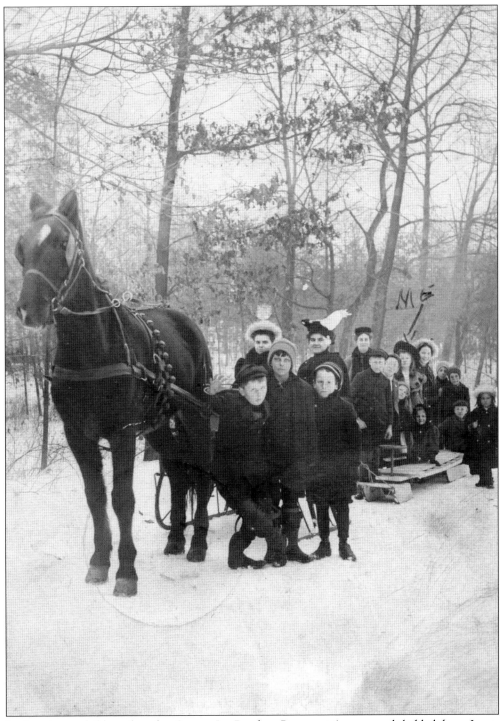

In the winter, children skated at Storms Ice Pond on Piermont Avenue and sledded down Large and Conklin Avenues on a horse-drawn sleigh. Almost all of the town went skating and for sleigh rides. (Courtesy Hillsdale Library.)

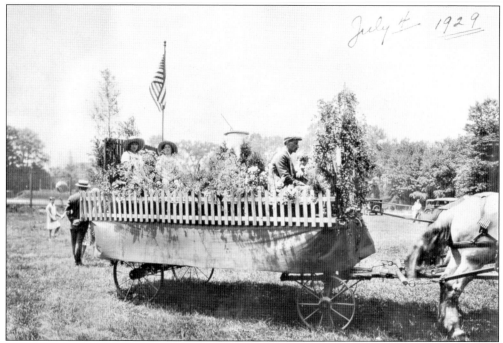

Henry Clendenny transports members of the Sun Dial Club, whose mission is to beautify the town, on July 4, 1929, their founding year. (Courtesy Hillsdale Library.)

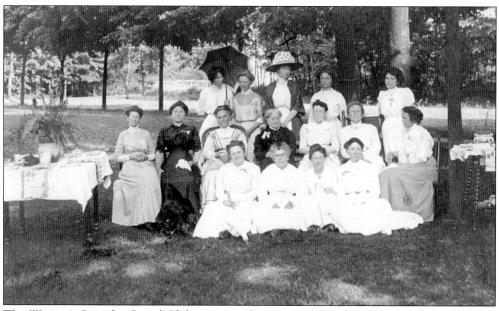

The Women's Saturday Social Club is pictured in Memorial Park in 1911. (Courtesy George Jepson Estate.)

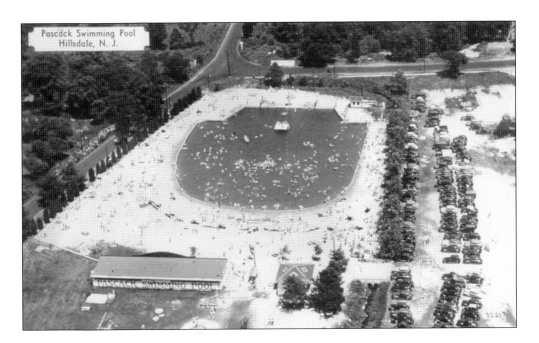

The Pascack Swimming Pool was located at the southwest corner of Piermont Avenue and Cedar Lane. The pool was a man-made lake that gained popularity in the 1940s when soldiers from nearby military camps would attend for recreation. On May 23, 1941, the Parks and Playgrounds Commission was organized. (Both, courtesy Hillsdale Library.)

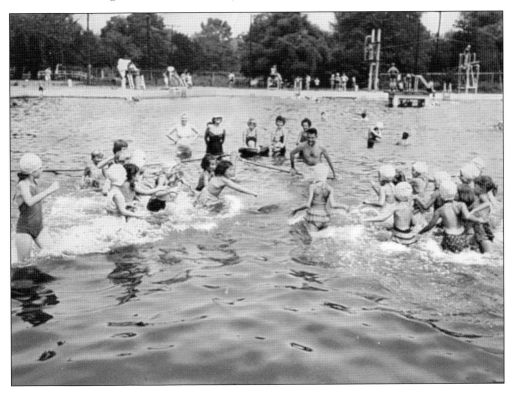

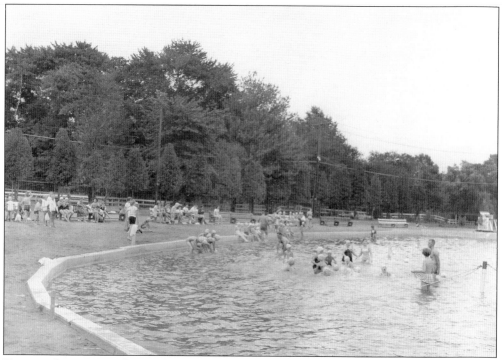

Here, an American Red Cross first aid swimming and diving water safety class is taught by one of the pool's lifeguards. (Both, courtesy Hillsdale Recreation Department archives.)

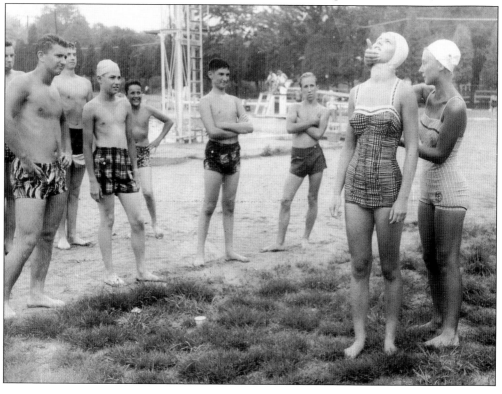

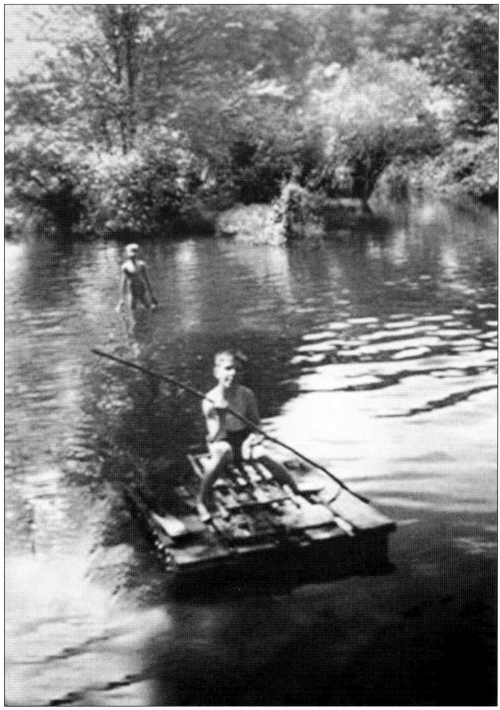

Ed McSpirt is pictured on a homemade raft in the Pascack Brook in the summer of 1942. (Courtesy McSpirt family archives.)

Hillsdale boys and girls sought amusement in the early 1900s by swimming in or going for walks along Pascack Brook. The water was so clean a person could drink it, and the fishing was plentiful. (Courtesy McSpirt family archives.).

Eight

FIRE, POLICE, AND PUBLIC WORKS

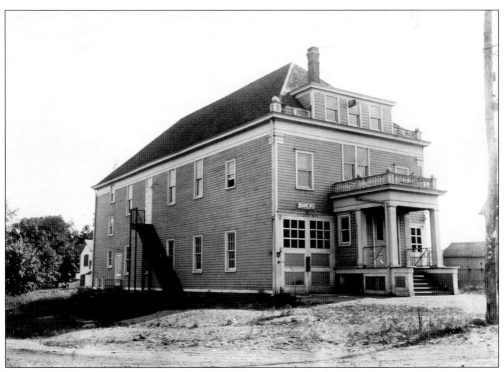

Fireman's Hall, seen here in the early 1900s, was a wooden building housing the firefighting equipment. Movies in the hall were viewed on the second floor, which was one large room with a stage at the far end of a balcony. Frequent dances, masqueraders, entertainments of all sorts, and town meetings were all held here. This site is now the parking lot for the borough hall and faces Central Avenue. In April 1902, the Hillsdale Fire Association and the Ladies Auxiliary were organized. (Courtesy Hillsdale Fire Department archives.)

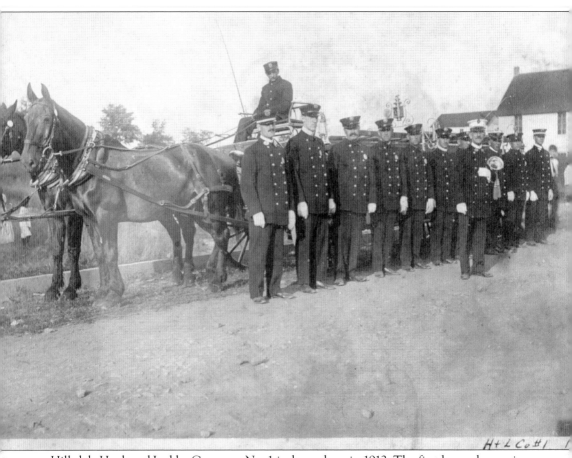

Hillsdale Hook and Ladder Company No. 1 is shown here in 1912. The first horse-drawn rig was acquired in 1907 by the Hillsdale Fire Department. Pictured from left to right are (first row) Capt. Harvey E. Herring; (second row, with two unidentified) Lt. L. Forbes, C. Saul, C.V. Shuttleworth, A. Bachman, J. Holland, W. Hering, G. Stegman, and F. Mead; (third row) a driver employed by Gardinier's Livery Stable (non-member.) (Courtesy Hillsdale Fire Department archives.)

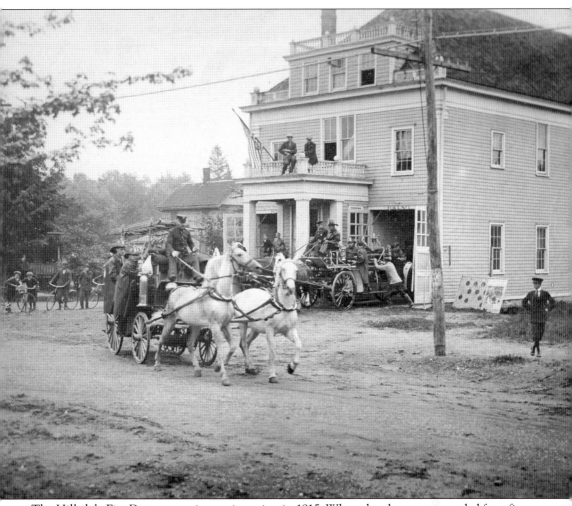

The Hillsdale Fire Department is seen in action in 1915. When the alarm was sounded for a fire call, horses would run up Park Avenue from Calvin Gardinier's Livery Stable, and the firemen would attach the horses their rigs. (Courtesy Hillsdale Fire Department archives.)

Fire chief Henry Werner (mayor) takes part in a training exercise with fellow HFD members in 1914. (Courtesy Hillsdale Fire Department archives.)

Members of the Hillsdale Fire Department are pictured in 1914. From left to right are Henry Werner (mayor), A. Deitz, C. Reilly, L. Forbes, N. Hering, and A. Fritz. (Courtesy Hillsdale Fire Department archives.)

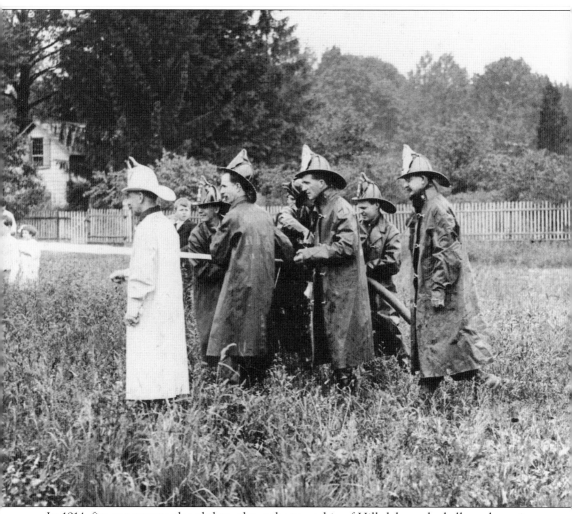

In 1914, fire gongs were placed throughout the township of Hillsdale, and a bell was hung in a wooden tower erected adjacent to fire headquarters. (Courtesy Hillsdale Fire Department archives.)

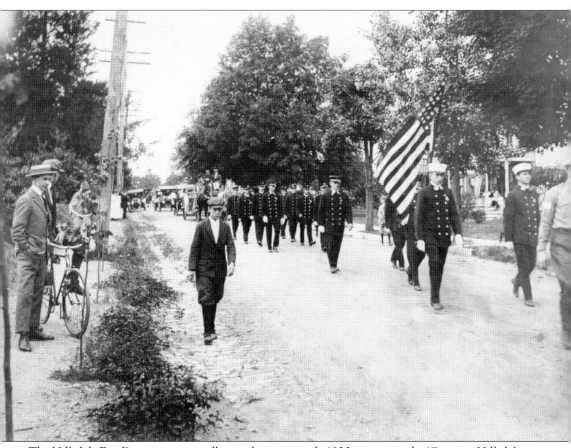

The Hillsdale Fire Department proudly marches in an early-1900s town parade. (Courtesy Hillsdale Fire Department archives.)

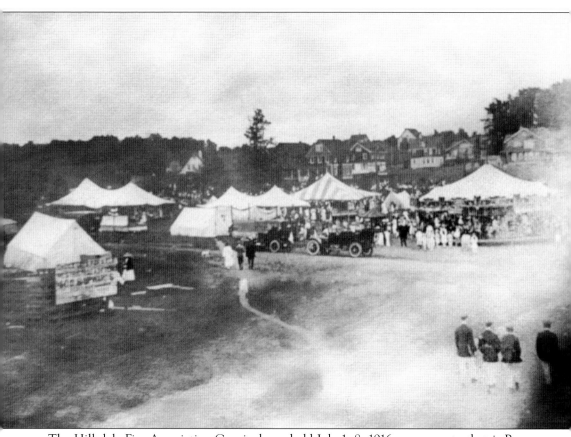

The Hillsdale Fire Association Carnival was held July 1–8, 1916, on property that is Bergen Avenue today. (Courtesy Hillsdale Fire Department archives.)

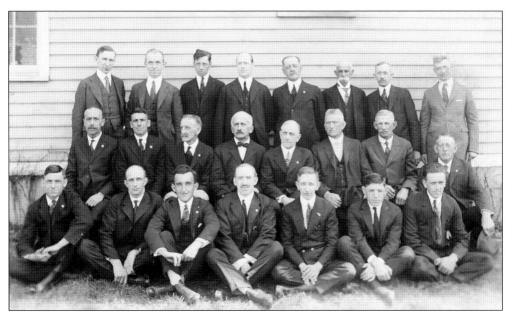

The Exempt Firemen's Association is pictured here in 1918. From left to right are (first row) B. Westphal, E. Demarest, P.E. Riley, C.V. Shuttleworth, A. Clausen, H. Bachman and H. Herring; (second row) G. Saul, C. Saul, J.W. Kinmonth, C. Demarest, H.J. Werner, L.C. Meyers, H.A. Hering, and A. Hogankemp; (third row) J. Clausen, G. Stegman, A. Bachman, J. Hansen, W. Banta, J. Ackerman, E.L. Greenin, and L.J. Forbes. (Courtesy Hillsdale Fire Department archives.)

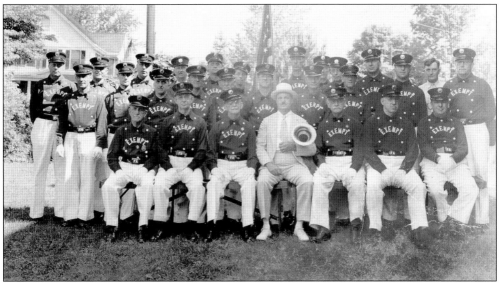

The Exempt Firemen's Association is shown in 1921. From left to right are (seated) Henry J. Werner (first mayor of Hillsdale), Leslie Fox, John Kinmonth (tax assessor), John Hansen (fifth mayor of Hillsdale), J.W. Banta, Clarence Shuttleworth, and Charles Saul; (standing) Cyrus Mead, Walter Higinson Sr., George Zengerle, John Brogeler, Wilbur Ottignon, Robert Long, Paul Nielson, George Buschbaum, Frank Mead, Thomas Tetlow, August Bachman, George Gossman, O.E. Phillips, John Mending, T. Clausson, Walter Hering, Joseph Farly, Fred Walker, William Diefenbach, Frank DeBaum Jr., and Albert Westervelt. (Courtesy Hillsdale Fire Department archives.)

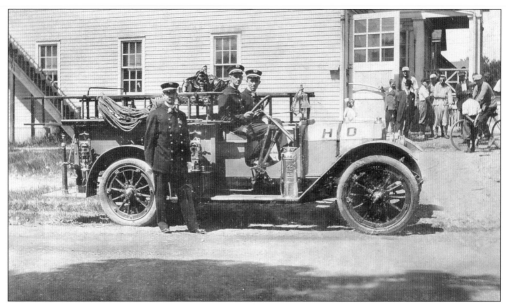

An early fire truck is seen outside of Fireman's Hall, photographed in the early 1900s. The first fire siren was installed on the roof of Fireman's Hall in July 1923. (Courtesy Hillsdale Fire Department archives.)

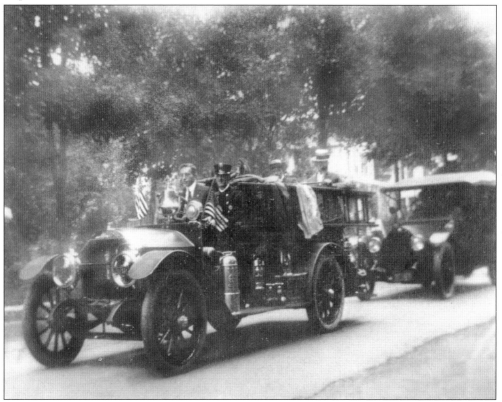

Hillsdale's first automotive hose truck was a 1926 Mack combination hook-and-ladder truck. Chairman George Saul is riding at the back of the truck. (Courtesy Hillsdale Fire Department archives.)

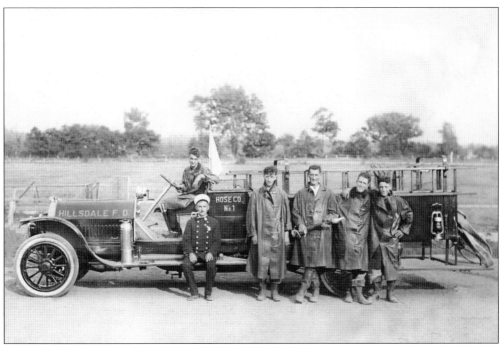

During 1914, the Hillsdale Fire Association purchased a Mathieson automobile, fitted it out, and called it Hose Company No. 1, replacing a horse-drawn vehicle. (Courtesy Hillsdale Fire Department archives.)

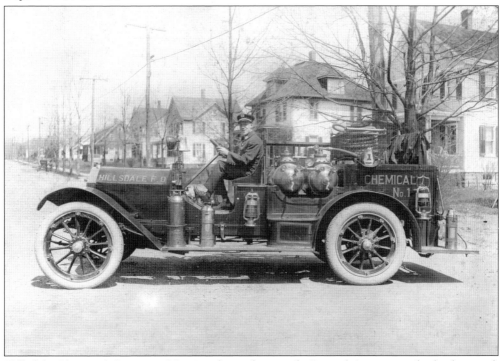

Hillsdale Chemical Company No. 1 is shown here with Central Avenue in the background. (Courtesy Hillsdale Fire Department archives.)

MOVING PICTURES

given by

American Legion
Hillsdale Post 162

FIREMEN'S HALL, HILLSDALE, N. J.

on

WEDNESDAY, APRIL 19, 1922
7:00 AND 9:00 P. M.

TICKET - - ADULTS 35 CENTS
CHILDREN 20 CENTS AT THE DOOR

This 1922 ticket was used for admittance to Fireman's Hall to watch silent movies on a Saturday evening in April. The films shown there had some of the following actors in them: Pearl White, Ruth Rowland, Dorothy Dalton, Charlie Chaplin, Doug Fairbanks Sr., and Mary Pickford. The famous horror films *The Hooded Terror* and *The Man-Ape* were featured and enjoyed by residents. (Courtesy Hillsdale Fire Department archives.)

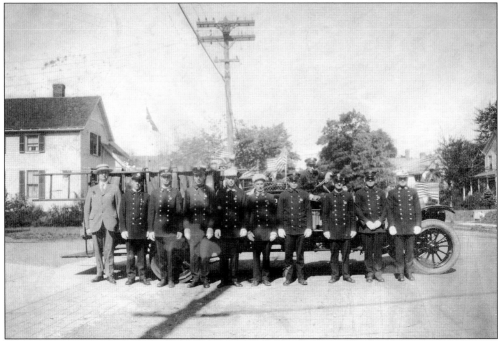

Pictured here is the Hillsdale Fire Department Hose Company No. 1 in 1927 with Park Avenue in the background. Pictured from left to right are John Hafeman (fire commissioner and former mayor), George Buschbaum Jr., George Zengerle, Wilbur Ottignon, Jacob Ackerman, Frank DeBaun Sr., Eugene Soubie, Charles S. Westphal (in the driver's seat), George Buschbaum, Charles Naden, and William A. Farley. (Courtesy Hillsdale Fire Department archives.)

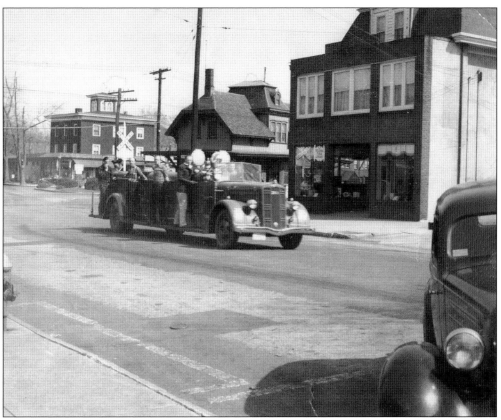

A 1941 Ward LaFrance combination hook-and-ladder truck is driving west on Hillsdale Avenue. In the background, the public library is located in the Leddy Building on Hillsdale Avenue. The library opened at this location on January 27, 1936, after cooperation of all citizens to make it possible. This Second Empire–style building served several functions throughout its history, including a post office, library, and coal and oil depot. (Courtesy Hillsdale Fire Department archives.)

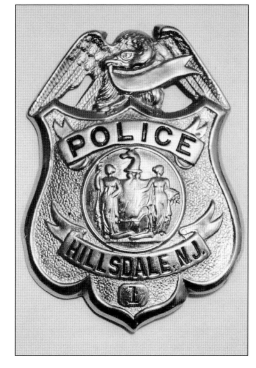

Seen here is Hillsdale constable badge No. 1. This badge was issued and worn by Alpheus Rawson in the mid-1920s. The badge remained in the Hillsdale Police Department's chief's office for all of these years and was recently found by police chief Elwood Stalter in 2011. (Courtesy Hillsdale Police Department archives.)

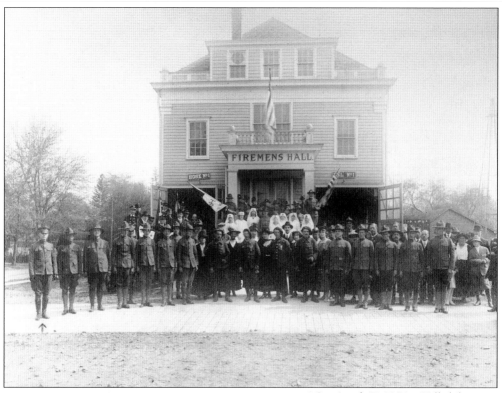

On April 17, 1917, a Hillsdale Loyal League was formed and duly recognized by the township committee. Fifty-three members, led by their chief, H.I. Knickerbocker, were sworn in as special police. (Courtesy George Jepson Estate.)

Alpheus Rawson is shown here on the south side of the Riley Building in 1916. On April 5, 1916, a township resolution offered a reward of $100 for the arrest and conviction of individuals who had burglarized homes in Hillsdale township. In August 1916, two officers of the New Jersey Detectives Association are appointed for an indefinite period to take turns watching incoming trains, looking for "questionable characters." They served one month. (Courtesy Rawson family archives.)

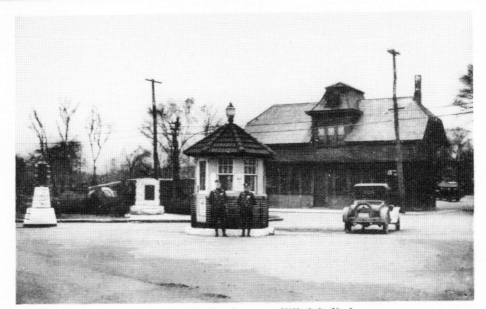

Hillsdale Station Square ~ Hillsdale N. J.

Hillsdale Station Square is featured on this early postcard. The Board of Trade donated this police booth on Christmas Day in 1925. Resident John Henry Olley helped build the kiosk. The first police car, a Chevy Roadster, was purchased in 1926. The first traffic light, seen at left in the photograph, was installed in 1927 at the intersection. Also seen in this photograph was a cannon that eventually got sacrificed for scrap metal during World War II. (Courtesy Hillsdale Police Department archives.)

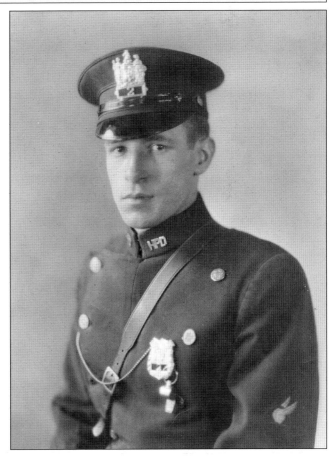

Patrolman R. Frank Stoeckel was appointed in January 1930. Stoeckel was a resident of Hillsdale who lived in the Glenbrook section at the time of his appointment. (Courtesy Hillsdale Police Department archives.)

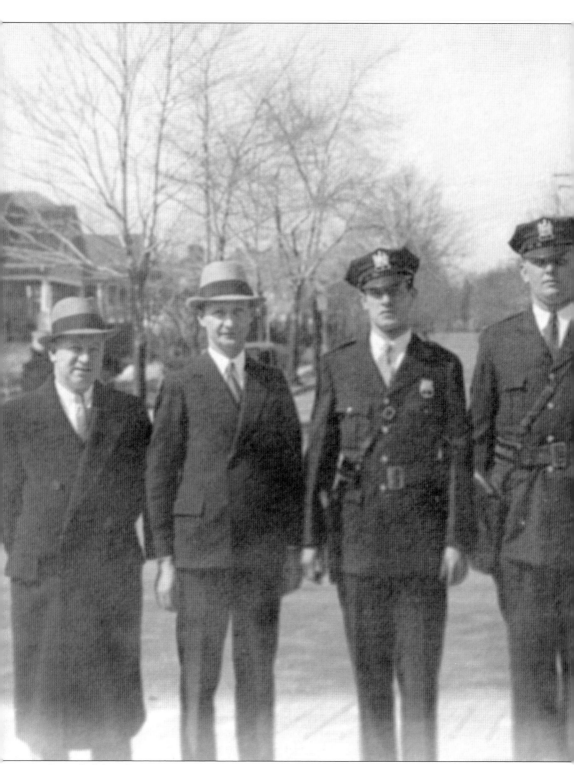

The Hillsdale Police Department showcases its new winter uniforms in 1934 on Central Avenue. Pictured are, from left to right, Commissioner G. Hobbs, Councilman William B. Terry, patrolman

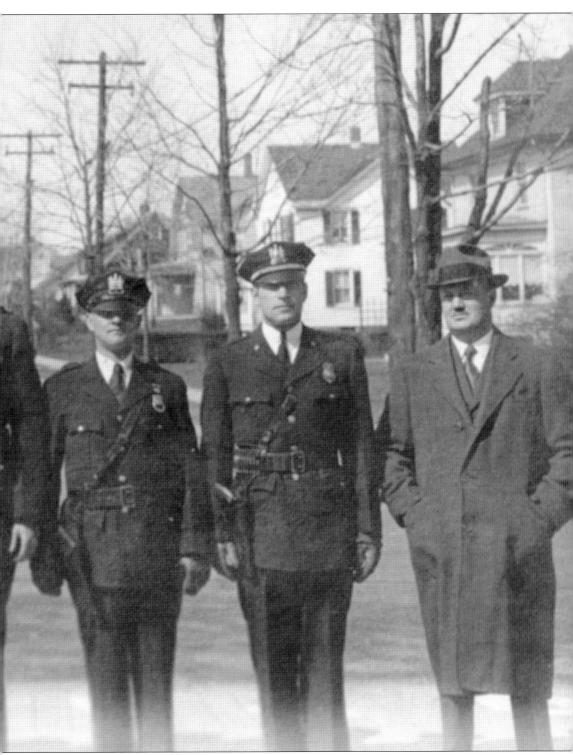

Frank Stoeckel, patrolman Julius Beissbarth, patrolman Henry Koelsch, Chief William Bulach, and Mayor John G. Hansen. (Both, courtesy Hillsdale Police Department archives.)

POLICE OFFICIALS AT HOLDUP INVESTIGATION

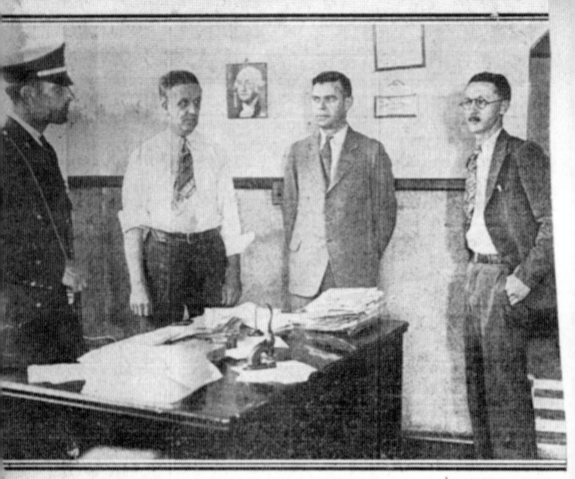

Edward Hauck (right), teller in the Hillsdale National Bank, tells police officials how he was held u
lay by armed bandits. Police Chief Bulach is on left, Police Commissioner Harvey E. Hering, i
of investigation, is in shirt sleeves, while next to him is W. Merle Hoffman, cashier of the ban
s escaped with $5,087.

Edward Hauck (right), a teller at the Hillsdale National Bank, tells police chief William Bulach (left) and police commissioner Harvey E. Hering (second from left) how he was held up by armed bandits. W. Merle Hoffman (second from right) was cashier of the bank at the time the robbers escaped with $5,087 in 1933. (Courtesy Hillsdale Police Department archives.)

Patrolman R. Frank Stoeckel is pictured here in the 1930s. Stoeckel eventually served as the chief of police beginning in 1945 and ultimately retired in 1968 after 38 years of honorable and dedicated service to the borough. (Courtesy Hillsdale Police Department archives.)

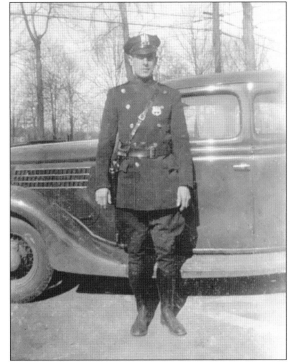

A 1937 Ford, driven by Chief Koelsch, was involved in a fatal pedestrian accident at the intersection of Hillsdale Avenue and Magnolia Avenue. Chief Koelsch was cleared of any blame in the death of victim, Charles Saul. (Courtesy Hillsdale Police Department archives.)

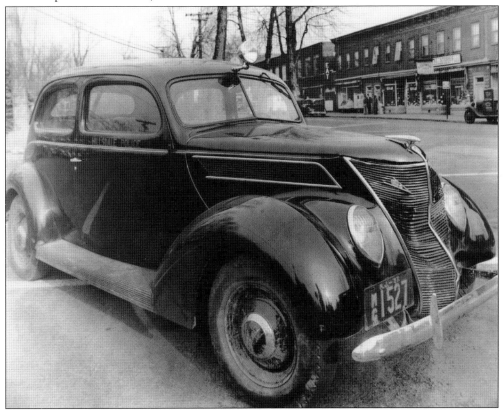

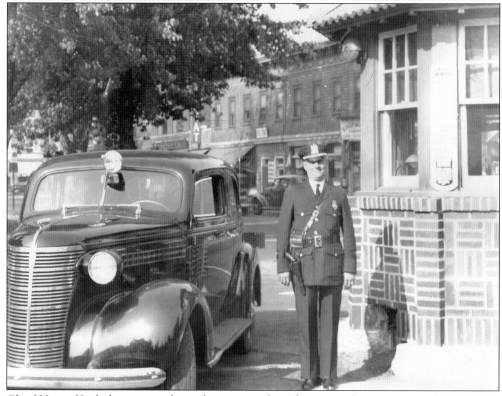

Chief Henry Koelsch is pictured standing next to his Chevy patrol car in 1938. That same car was traded in a year later and enabled the borough to purchase a new car for $198.20, figuring the trade-in value. The bell seen on the police booth was meant to alert an officer on foot patrol of an incoming call. (Courtesy Hillsdale Police Department archives.)

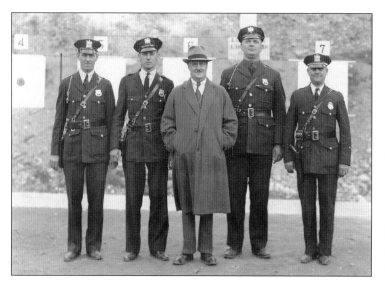

Members of the Hillsdale Police Department were photographed in 1938 at the Park Ridge pistol range. From left to right are patrolman Charles Naden, patrolman R. Frank Stoeckel, Mayor John Hansen, patrolman Julius Beissbarth, and Chief Henry Koelsch. (Courtesy Hillsdale Police Department archives.)

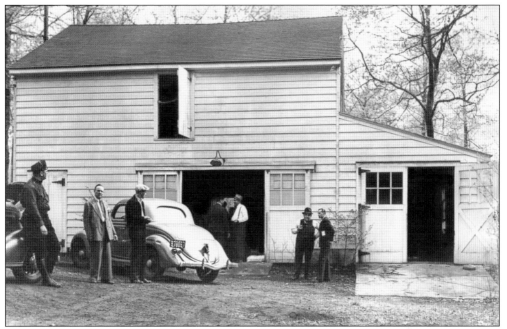

After a search on April 29, 1938, detectives located a still on Frank Liveright's estate on Wierimus Lane. The still had a 1,000-gallon capacity and was estimated to have yielded $2,500 in alcohol weekly. This was one of Bergen County's most sophisticated stills that was located by police. (Courtesy Hillsdale Police Department archives.)

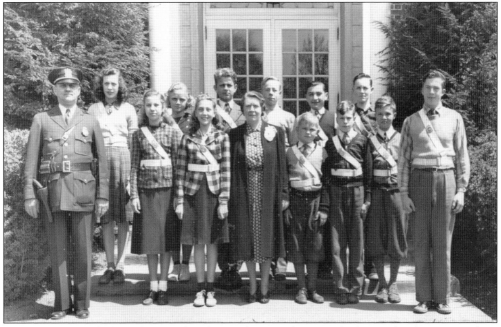

Chief Henry Koelsch and Ann Blanch Smith were photographed outside of George White School in 1942 with members of the Junior Police Patrol. The members were treated to a trip to Washington, DC, escorted by the Chief Koelsch and Smith. This tradition continued for many years. (Courtesy Hillsdale Police Department archives.)

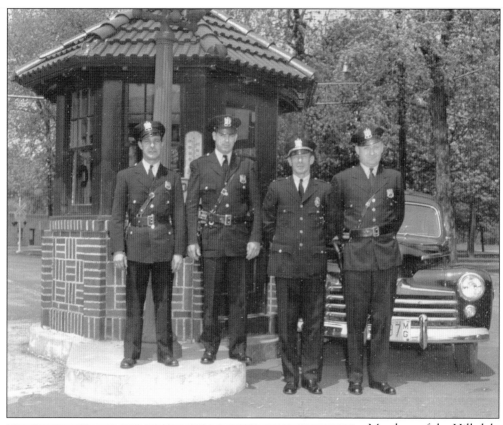

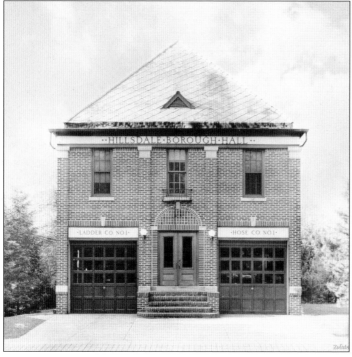

Members of the Hillsdale Police Department were photographed in 1948 for the 50th anniversary of the borough. From left to right are patrolman George Scott, patrolman John Greve, Chief R. Frank Stoeckel, and patrolman Gerry Schmidt. (Courtesy Hillsdale Police Department archives.)

Hillsdale Borough Hall is pictured here in 1948. This image shows the second makeover of the hall, before its destruction in 1973. (Courtesy Hillsdale Police Department archives.)

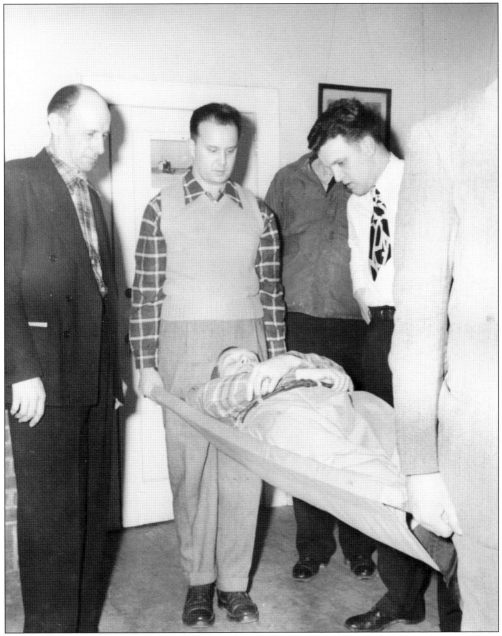

The Hillsdale Civil Defense Team is shown above. Chief R. Frank Stoekel (left) and Calvin Piper (right, wearing tie) look on as members practice basic first aid at the Hillsdale Borough Hall. (Courtesy Hillsdale Police Department archives.)

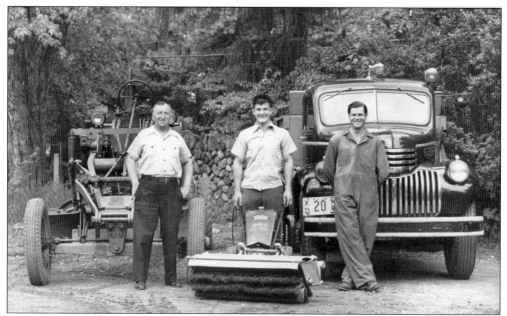

Hillsdale Department of Public Works employees are photographed with their equipment, a road grader, and a gasoline-operated sweeper in 1948. From left to right are William Diefenbach, foreman; F. Raute; and F. Markle. The first assigned road department started in 1925 and was led by Axel Gustafson. At that time, their equipment consisted of a wheelbarrow and other hand tools. (Courtesy Hillsdale Department of Public Works archives.)

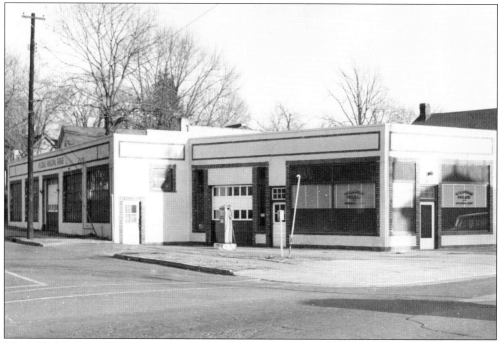

The Hillsdale borough garage and police headquarters are shown here in 1948. Court was also held in the front section of the borough garage. This building was located at the corner of Washington Avenue and Broadway and was knocked down in 1972. (Courtesy Hillsdale Library.)

Nine

SERVING TOWN AND COUNTRY

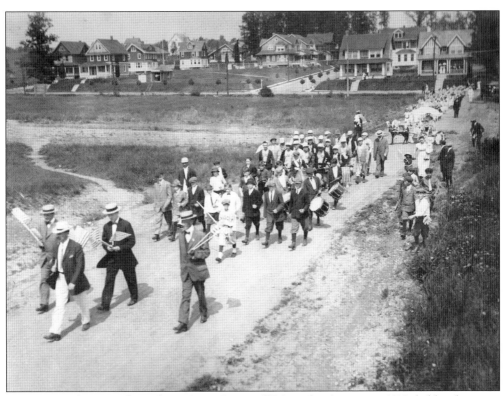

A town parade is marching down Cross Street off Magnolia Avenue in 1913, led by chairman George Saul and the township committee. Also marching in the parade were T.I. Haubner's Fife and Drums Corps and the Hillsdale Fire Department, then led by Chief C.E. McCleary, who also served as the township's police chief. (Courtesy Hillsdale Borough archives.)

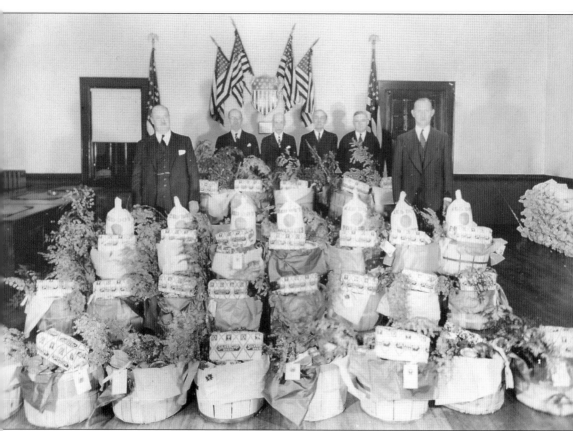

Mayor John Hansen and the rest of the governing body are shown at the Hillsdale Borough Hall supporting a food drive during World War II. Because of meat rationing and increased cost of groceries, a number of Pascack Valley families started their own backyard poultry farms. Gasoline rationing was a major sacrifice for some and an excuse for dishonesty for others. In Hillsdale, a firefighter was accused of draining the gas tank of one of the fire trucks. A cannon and machine gun were taken from Station Square Park for scrap metal, and the bell from the school was sacrificed as well. (Courtesy Henry Koelsch Estate archives.)

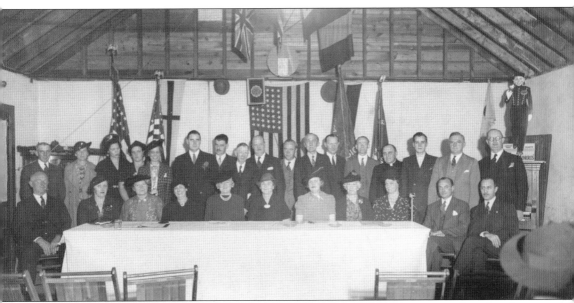

Members of the Hillsdale Council are shown at the American Legion hut. Every Saturday, the women of Hillsdale took homemade cakes, candies, and boxes of magazines, books, and records to soldiers who were staying at two antiaircraft station camps nearby. Additionally, the soldiers were invited to share holiday dinners in various Hillsdale homes. (Courtesy American Legion Post 162 archives.)

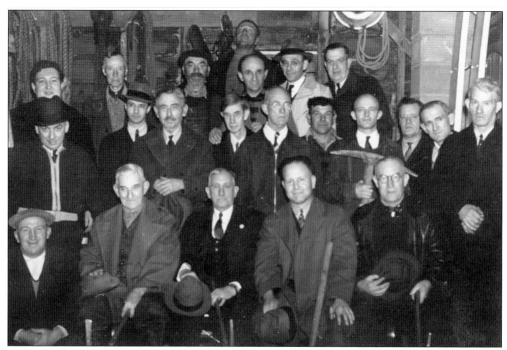

With the threat of air raids, many important committees formed, including the Demolition and Rescue Squad with 31 men. A committee to consider light, water, gas, and electric as matters of hazard and need was also formed. (Courtesy Hillsdale Library.)

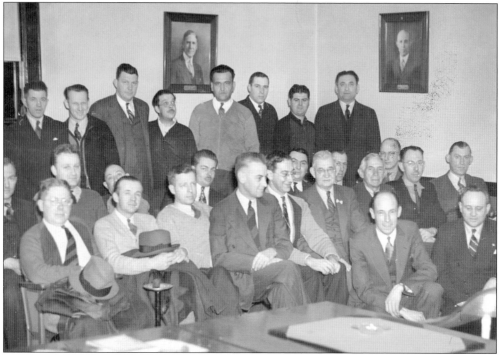

The Hillsdale Civil Defense Team is pictured at the Hillsdale Borough Hall in the 1940s. Chief R. Frank Stoeckel is seen kneeling at right. (Courtesy Hillsdale Library.)

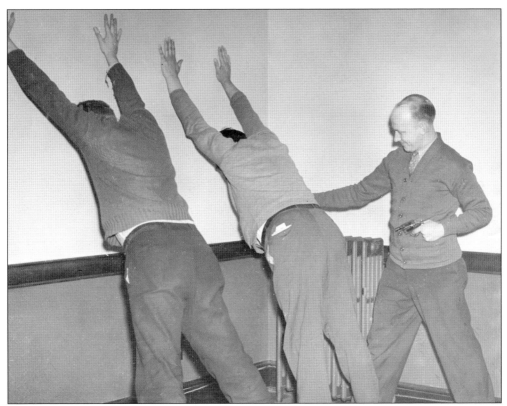

By the autumn of 1941, a police auxiliary of 22 men and a fire auxiliary of 24 men had been organized. The police auxiliary received 10 weeks of training in police practice and procedure at the Hillsdale Borough Hall. During the fourth week of training, laws for arresting someone and the methods of arrest (warrants, authority to arrest, etc.) were taught, according to the police reserve training manual. (Both, courtesy Hillsdale Police Department archives.)

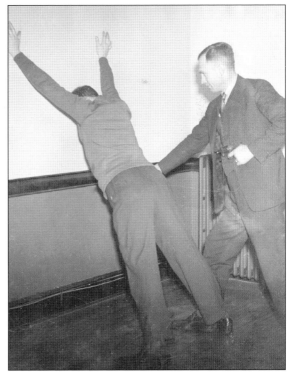

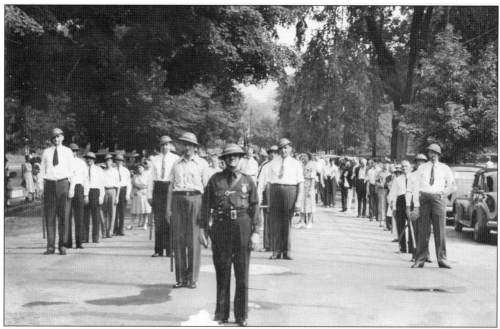

Hillsdale police chief Henry Koelsch and members of the American Legion Post 162 lead the Fourth of July parade in 1942 on Magnolia Avenue. (Courtesy Hillsdale Police Department archives.)

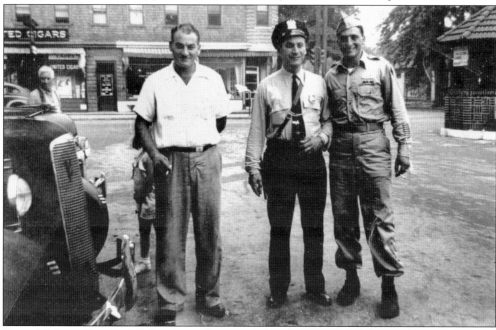

Special Police officer Paul Daher (center) is pictured in downtown Hillsdale with an unidentified man (left) and a World War II serviceman (right). After the attack on Pearl Harbor occurred, the chief requested an additional regular officer, and Daher was hired for that position. The chief's fear was that crimes such as sabotage and espionage would occur in town. He requested to the mayor and council that the police booth be manned day and night to monitor air-raid alarms. (Courtesy Rose Daher.)

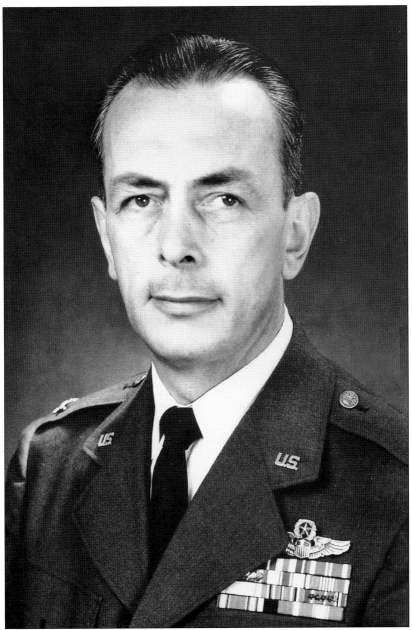

Col. Frank A. Hill, a Hillsdale resident, flew 166 air combat missions in Europe and North Africa during World War II. He was credited as the first pilot of an all-American group to down a German fighter plane in combat over Dieppe, France. He became the first ace of the 31st Fighter Group in 1943 and the group's commander. Colonel Hill entered the Army Air Corps in 1939. As a second lieutenant, he saw action early in the war and rose quickly through the ranks. He flew combat missions over North Africa, Sicily, and other parts of Italy. He achieved fighter ace status with 7.5 enemy planes to his credit. During his 30-year career in the US Air Force, Colonel Hill received the Distinguished Flying Cross, the Silver Star, the Air Medal with 19 oak leaf clusters, Legion of Merit with two oak leaf clusters, and five Air Force Commendation Medals. Colonel Hill was inducted into the New Jersey Aviation Hall of Fame in 1992. (Courtesy Frank Hill family archives.)

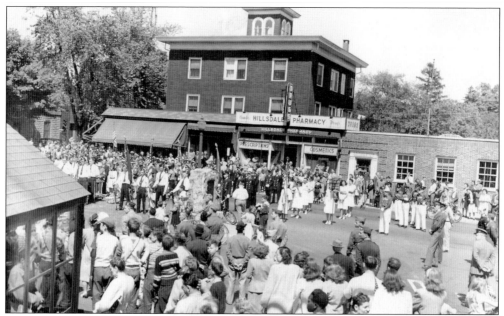

One of the brightest moments for Hillsdale during World War II occurred on September 14, 1943, when most of Hillsdale's population turned out to welcome home 24-year-old Col. Frank A. Hill, who was a true hero during the conflict. Mayor Edmund Greenin (fourth from left) and Councilman Harry Gunther (with microphone) at the receiving post. A World War II honor roll was erected under the auspices of the Hillsdale Fire Department and was presented to the borough on Decoration Day 1942. The fire department maintained this honor roll and edited names until the close of World War II, at which time it was donated to the Hillsdale American Legion Post 162, where it remains today. (Both, courtesy Hillsdale Library.)

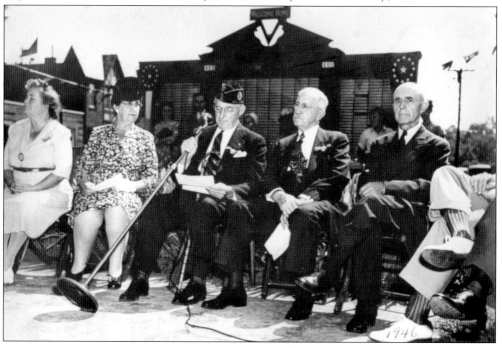

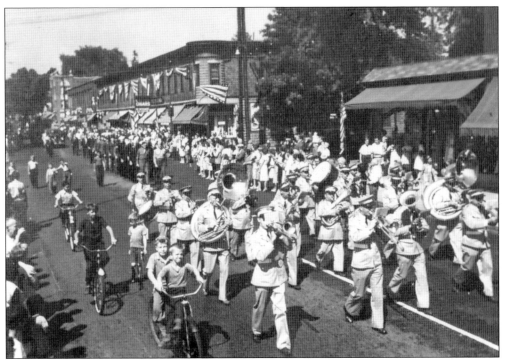

Young children ride their bikes down Broadway at the welcome home parade for Frank Hill. (Both, courtesy Hillsdale Library.)

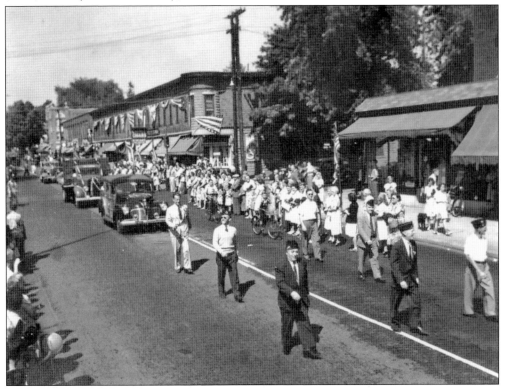

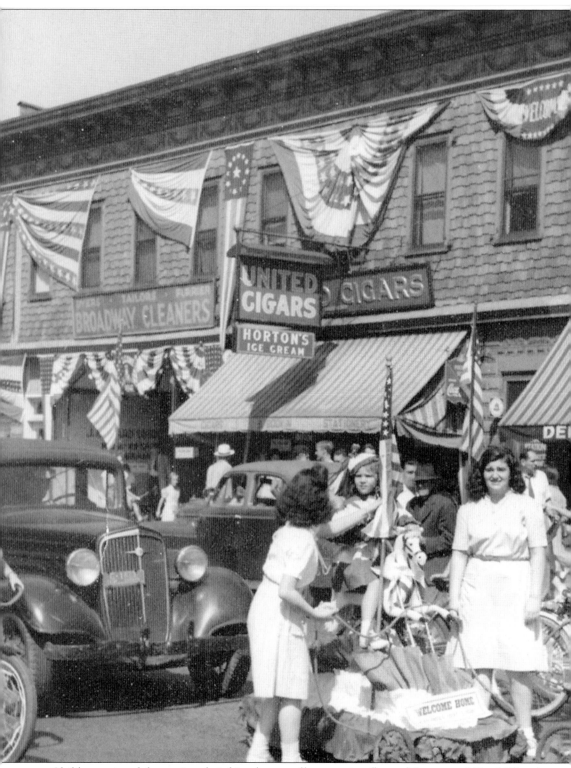

Children enjoyed decorating their bicycles as well as creating floats. (Courtesy of Carol Blinn.)

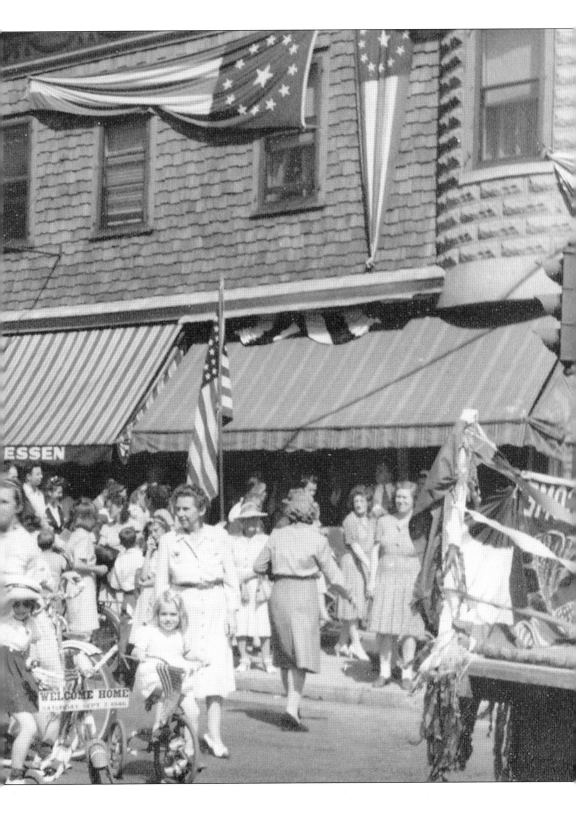

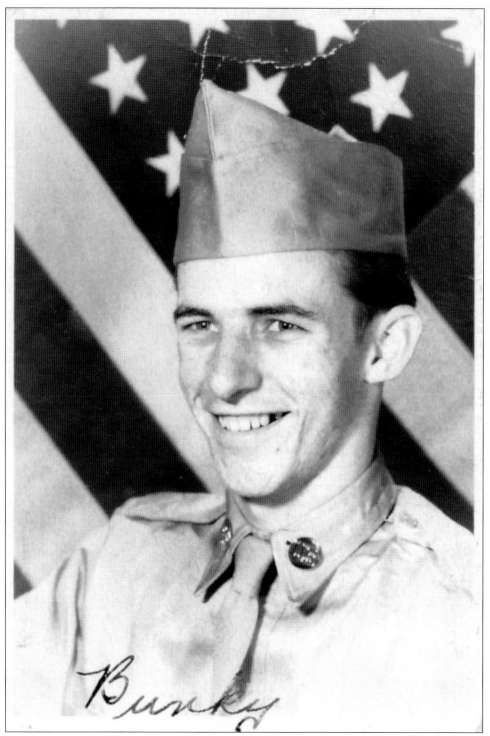

Army private (E-2) Albert "Bunky" Rawson, a Hillsdale resident, was killed in action while fighting the enemy in North Korea on April 25, 1953. He served in the 15th Infantry Regiment, 3rd Infantry Division. (Courtesy Barbara Rawson.)

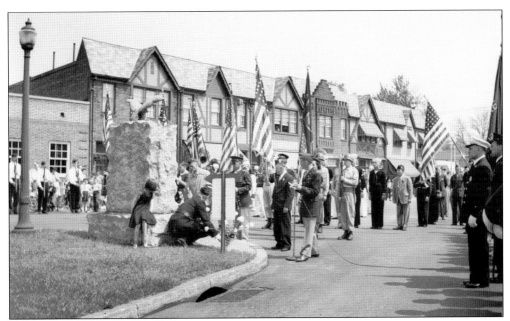

Members of the American Legion Post 162 pay respects to the residents who served in World War I. In 1921, a large boulder that was intended to be a war memorial was transported to Hillsdale on a flat car, and in attempting to transfer it to Memorial Park, the boulder broke away and fell to the ground. The citizens decided that the cost of raising the boulder and moving it to Memorial Park was prohibitive. It still remains today where it fell. By a special election held in March 1922, it was decided to erect a granite memorial to World War I servicemen on Broadway across from the train station. The monument was later relocated to Veteran's Park. (Courtesy Hillsdale Library.)

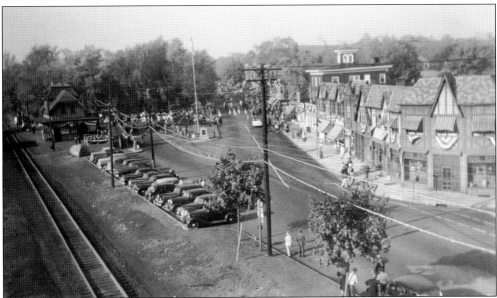

In October 1948, Hillsdale held a weeklong celebration to mark its 50th anniversary. This is a view from the water tower in downtown Hillsdale during the anniversary parade on October 16. The theme of the parade was along the lines of the Gay Nineties dress and customs. (Courtesy George Jepson Estate.)

DISCOVER THOUSANDS OF LOCAL HISTORY BOOKS
FEATURING MILLIONS OF VINTAGE IMAGES

Arcadia Publishing, the leading local history publisher in the United States, is committed to making history accessible and meaningful through publishing books that celebrate and preserve the heritage of America's people and places.

Find more books like this at
www.arcadiapublishing.com

Search for your hometown history, your old stomping grounds, and even your favorite sports team.

Consistent with our mission to preserve history on a local level, this book was printed in South Carolina on American-made paper and manufactured entirely in the United States. Products carrying the accredited Forest Stewardship Council (FSC) label are printed on 100 percent FSC-certified paper.

MADE IN THE USA